PRESTON
THROUGH TIME
Keith Johnson

AMBERLEY PUBLISHING

First published 2011

Amberley Publishing
The Hill, Stroud
Gloucestershire, GL5 4EP

www.amberley-books.com

Copyright © Keith Johnson, 2011

The right of Keith Johnson to be identified as the
Author of this work has been asserted in accordance
with the Copyrights, Designs and Patents Act 1988.

ISBN 978 1 4456 0589 0

British Library Cataloguing in Publication Data.
A catalogue record for this book is available from
the British Library.

Typeset in 9.5pt on 12pt Celeste.
Typesetting by Amberley Publishing.
Printed in the UK.

Introduction

The history of Preston, Lancashire, stretches back over 1,200 years, and for almost a 1,000 of those years it was simply a small, rural market town. It enjoys an elevated position on the northern side of the River Ribble and generated a certain wealth, being home to the landed gentry and described as a corporate market town, with the title 'Proud Preston' bestowed upon it. Priests and friars, lawyers and distinguished gentlemen all contributed to the town's rich past. When Lady Oxford came to call in the eighteenth century she remarked, 'It is a very clean pleasant town consisting of two large streets, wherein many of the neighbouring gentry have good winter houses.' She remarked also that, with regards to the politeness of the inhabitants, none could compare.

Of course, when the cotton industry came calling at the dawn of the nineteenth century, everything changed. Cotton mills and factories, endless rows of terraced cottages, railways, roads, canals and all that constituted industrial development was reluctantly embraced.

Fortunately, along with industrial progress, technology advanced and no longer would we have to rely on engravings and paintings to record our history. By 1858, the town had a handful of photographers and the camera was gaining popularity. Professional photographers were emerging and soon a cavalcade of cameras would record the development of Preston. We are, of course indebted to their foresight and determination to record our history. Pictures of people, property, parks and processions all gave us an insight into what life was like from the reign of Queen Victoria and ever onwards.

I hope the photographs within this book give a glimpse of Preston's development from the grimy, industrial Victorian days through into a thriving university city at the heart of Lancashire. It is apparent from the images within that Preston is an ever changing place, and often more than once at a particular location. So indulge yourself, linger in the past for a few nostalgic hours and recall the people and places that have been and gone during your lifetime, or indeed, the lifetime of your parents. Join me on a photographic, picture postcard tour when the camera shutter clicked and history was recorded, thus allowing us to take a glimpse of how things were. History is often portrayed in black and white, but this book reveals a colourful past and I hope the images of present-day Preston reflect the progress made within the city.

Writing this book has allowed me to indulge in a journey back once more through the history of Preston, and to capture moments in time that have fascinated me. I hope that you are fascinated too.

Acknowledgements

I would like to thank the Preston Digital Archive, and in particular Richard H. Parker, for allowing me to use illustrations from their photographic collection, without which this book would not have been possible. The PDA brings pleasure to all who have an interest in the history of Preston. Of course, I must acknowledge the assistance given to me by the staff of Harris Reference Library, in delving into the archives. I am also grateful to the historians and photographers of old who recorded our history, so that we might have a glimpse of the past.

My appreciation also goes to the newspaper reporters of the *Preston Chronicle*, *Preston Herald*, *Preston Guardian* and *Preston Pilot* who chronicled events of their day. And, of course, my thanks go to the *Lancashire Evening Post*, a newspaper that has been in circulation for 125 years, and especially to the Deputy Editor, Mike Hill.

Besides my own collection of images and those from the PDA, I would like to thank Paul Gunson of the www.prestonlancs.com website for photographs, along with Glen Crook and others mentioned within the text, all of whom have helped to make this publication possible.

My thanks also to Pat Crook, for cheerfully checking my text and putting her literary skills at my disposal once again.

About the Author

Keith Anthony Johnson is Preston born and bred. His previous works include the *Chilling True Tales of Old Preston* series of books, *People of Old Preston* and *Preston Remembered*.

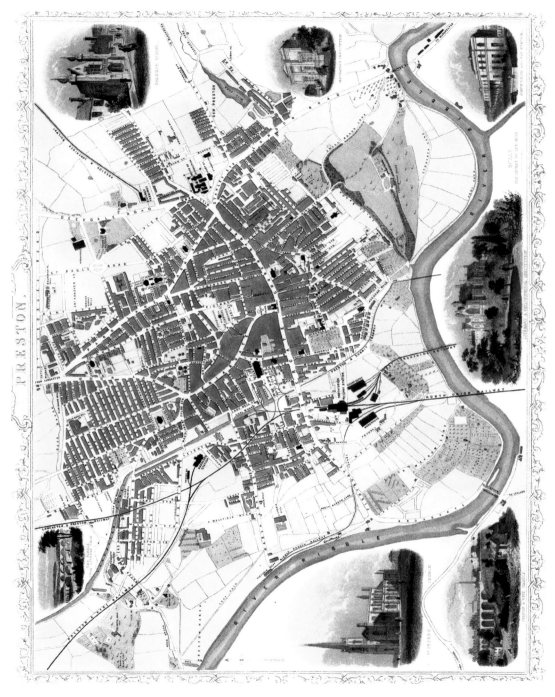

Map of Preston 1852

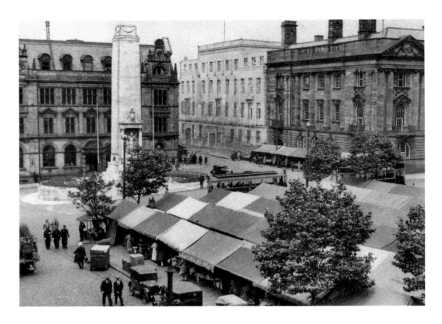

Market Place Viewed from Cheapside

A busy market day in 1936, with stalls spilling over onto Birley Street. The newly built Municipal Buildings can be seen alongside the Sessions House. To the left of the picture is the Central Post Office building opened in 1903. In 1987, when it was given a £½ million renovation it was described as the busiest building in town. It was vacated in 2002 when the post office moved to the Urban Exchange Arcade on Theatre Street. Below is a much quieter scene on a sunny spring day in 2011 with the Harris Museum & Library, officially opened in October 1893, looking resplendent and worth every penny of the £122,000 legacy that Edmund Robert Harris left for its erection. Hard to imagine now that once the Shambles stood there, where butchers carried out their trade. Or that bear and bull baiting was commonplace, and delinquents were punished here by means of the pillory.

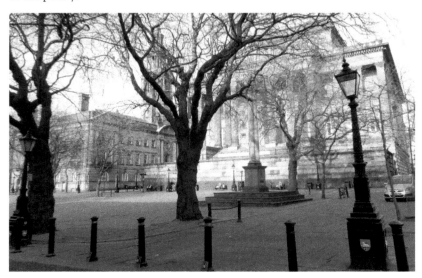

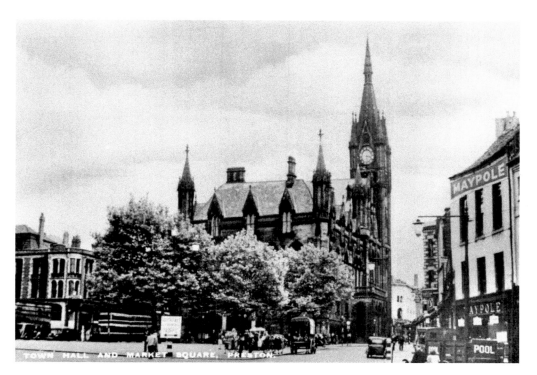

Market Place Looking Towards Fishergate

Seventy-five years separate these two photographs and reflect the ever-changing scene. The Gothic town hall, with its clock tower pictured c. 1936, is a distant memory, as are the days before supermarkets when shoppers flocked to the Maypole store on Cheapside to get their dairy products and wrapped lard or butter. The present-day view shows the newly clad Cubic – formerly Crystal House – standing on the town hall site. In front of that building stands the Obelisk, which was removed from its ancient site in 1853, and returned in May 1979 when Her Majesty the Queen unveiled the restored monument to celebrate Preston's Octocentenary. It is a reminder of the history of a place where mayors and bailiffs had gathered to discuss the town's affairs, friars held discourse and the devout prayed, and for centuries the Guild Merchant has been proclaimed.

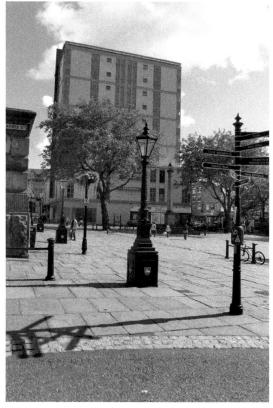

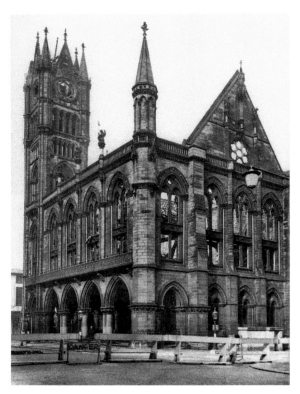

Preston Town Hall, 1947

Pictured within days of the devastating fire of 15 March 1947, the town hall building is a blackened ruin. It was formally opened in October 1867, built of Longridge freestone and it cost £69,412 to create. With its graceful spire standing 176ft tall, a lofty tower housing a four-dial clock and abell on the hour that could be heard for miles around – it could not be ignored. It was built to the design of Sir George Gilbert Scott, and with council chamber and concert hall it was at the heart of civic life until the fire. There was a determination to restore the building during the following years and, although the tower had to be demolished, part of the building was made suitable for council purposes and other events. The last public event took place in August 1961 when St Joseph's organised a coffee evening and fashion show. Eventually the building was demolished in 1962.

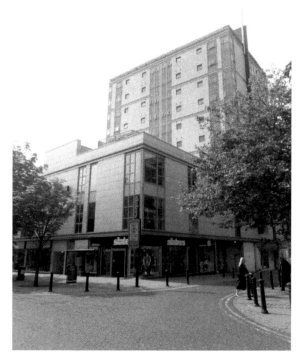

The Cubic – Formerly Crystal House

Once the town hall had gone, the site was acquired by a Land Company who resolved to build a shopping and office block. They wasted little time and it was completed by July 1964 to stand on Preston's Market Square. Unveiled as Crystal House, it had plenty of critics who still mourned the loss of the beloved town hall. Through the decades, a number of excellent retailers have operated around its perimeter and prospered in a busy location. Recently given a facelift and now offering tenth-floor penthouse apartments, with great views of the city centre, it seems to have answered some of its critics. The newly clad structure is pictured from the corner of Fishergate and Birley Street and is known as the Cubic.

St John's Minister Church, Church Street

The site of the Preston parish church has been hallowed ground since AD 670. The church is proud to declare it has survived the Black Death, the Reformation, the Civil War, the Great Depression and numerous other tribulations. In the past it has been known as St Theobald's and St Wilfred's before being dedicated to St John the Baptist. The current building dates back to 1854/55 when almost all of the church was pulled down and rebuilt. Thrice married Canon John Ower Parr was the vicar of Preston whilst all the rebuilding was taking place, serving the parish from 1840 until his death in 1877. It is true to say little has changed in the two views over a century apart, although the gravestones and railings have now gone. Nicholas Grimshaw, twice Guild Mayor, was amongst the prominent folk buried here in the nineteenth century. Following the granting of City status to Preston, the parish church underwent much-needed restoration work and was unveiled as St John's Minister in June 2003.

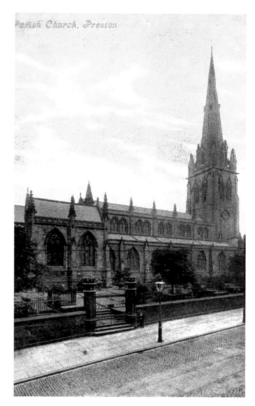

Parish Church, Preston

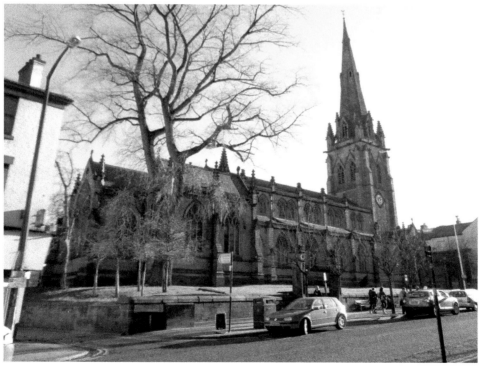

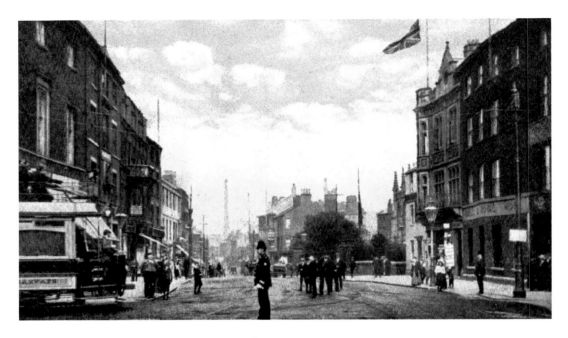

Church Street Viewed from Lancaster Road

In this postcard view *c.* 1912, the left side of Church Street just prior to it being redeveloped. The old bank building would soon be replaced by the Preston Savings Bank, and alongside it the lavish Empire Theatre, opened in 1911. To the right is the ancient Bull & Royal Hotel, the place for genteel folk to stay. Alongside it is the Conservative Working Men's Club and next to that is the Eagle & Child public house situated at the top of Stoneygate. The present-day scene is not quite so grand; the bank that became TSB Preston is now abandoned and the Empire Theatre, which became a popular cinema and finally a bingo hall, was knocked down in 1976; a restaurant and a Tesco Express, with apartments above, occupy the site. The buildings to the right remain although the premises are used for different purposes, except for the Eagle & Child – it was swept away in 1931 making the entrance to Stoneygate much wider.

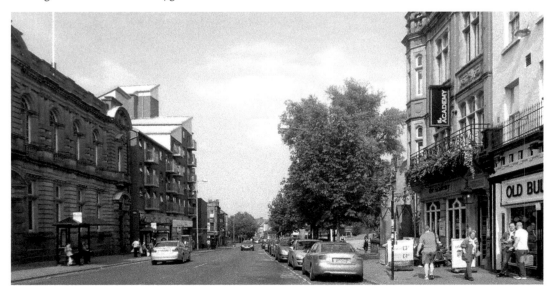

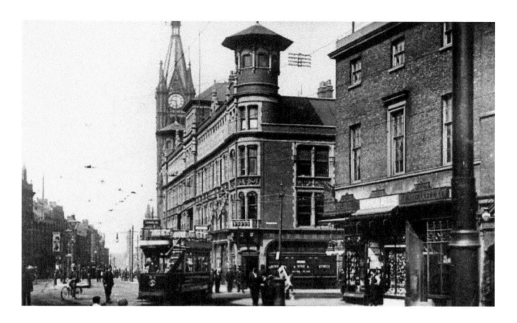

Church Street and Lancaster Road Corner

It would seem that dentistry was a lucrative business in late-nineteenth-century Preston because local dentist Nathaniel Miller had enough of a fortune to invest in the property business. The Miller Arcade, built on a steel structure, still stands on the corner and was the town's first purpose-built shopping centre, opening in 1901. At the corner of the Miller Arcade Hayhurst's King's Arms can be seen. The older image captures a moment in 1907 as an early electric tram turns into Church Street. On the corner of Church Street then was Breakall's the brewers, later replaced by Starkie & Co. the outfitter's, who have now given way to Richer Sounds. If you view the skyline between the Edwardian image and the present one, the imposing town hall clock tower and the corner towers atop Miller Arcade have now gone. It is still a busy junction these days with buses replacing trams since 1935.

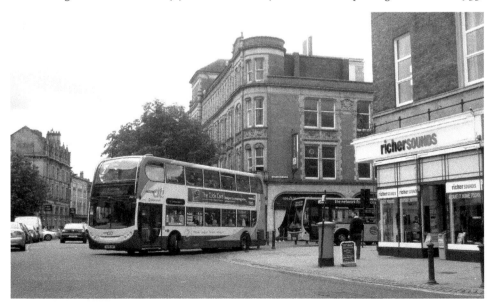

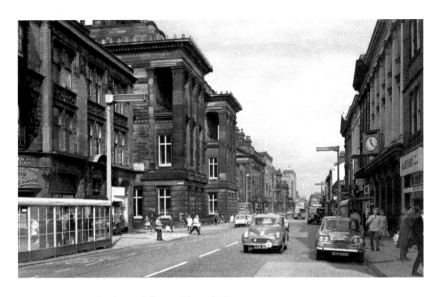

Lancaster Road Viewed from Church Street

A busy Lancaster Road, constructed back in 1827, is captured on this postcard view *c.* 1967. A learner driver approaches the Church Street junction as pedestrians hurry along and a queue of people wait in the bus shelter on the left outside the Miller Arcade. Beyond the Arcade can be seen the Harris Museum, the Sessions House and the Municipal Building. In the recent photograph a taxi rank stands where the bus shelter stood, and a Preston Bus, operated by Rotala, heads to Farringdon Park as the trams did in times gone by. The Harris Museum building still dominates the skyline, with trees now visible centrally, and to the right the sign of the Stanley Arms can be seen. This inn carried the name 'Knowsley Arms' for a period up until 1972, when it was given a new lease of life with an Edwardian-style renovation and a return to its old name. The Stanley Buildings to the right are still home to a variety of shops and retailers.

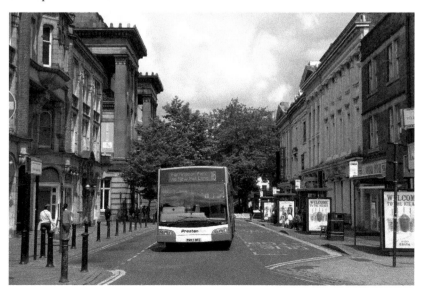

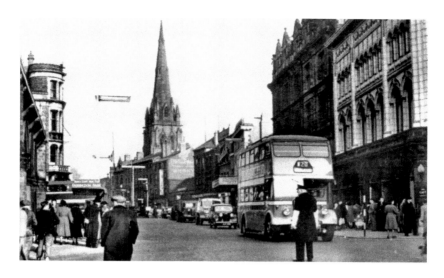

Top of Fishergate Looking Towards Church Street

This image, captured in 1961, looks towards the spire of the parish church on Church Street. With a heavy flow of traffic to contend with a policeman is on points duty. In the days before the Central Bus Station, a queue forms at the Farringdon Park bus stop. In the foreground to the right is the store and café of E. H. Booth who operated in the town centre from 1859; firstly from the Market Place and then Fishergate, until its closure in 1988. Happily, the fine building is now occupied by Waterstone's. The building next door became a National Westminster Bank and was the scene of a daring robbery in September 1988 with hostages taken. Nowadays the premises are a public house called Wall Street. The Odeon cinema that advertises films – Continuous Daily – showed its last film in 1992. In the present-day picture there is still plenty of traffic to contend with, but only the buses and taxis are allowed down Fishergate. Once more, greenery abounds and the tree obscures the view of the church steeple.

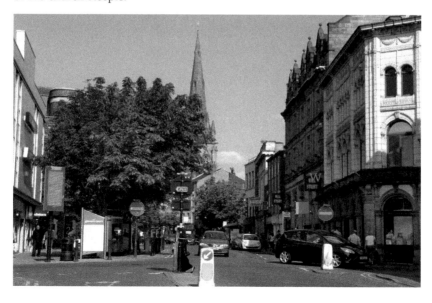

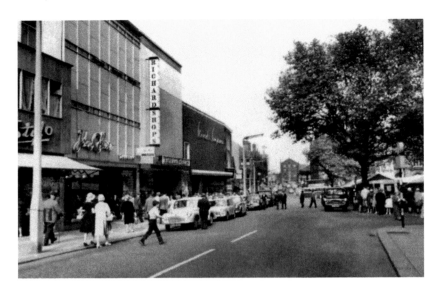

Cheapside Viewed from Fishergate

This busy scene *c.* 1962 shows Cheapside in a new era as familiar high street retailers display the façade to match their image. Stead & Simpson, Richards and Stylo all offer the latest for the fashion-conscious period. Not forgetting John Collier, the tailor's, with their slogan 'The window to watch'. These days it is Ann Summers on the corner with the slogan 'Tickle My Fancy'. The other retailers have also changed and the façades altered, but it remains a popular place to shop. Amazingly, one building that remains unaltered, just out of view, is the small gable-fronted shop of seventeenth-century origins that is the Thomas Yates jeweller's shop. It serves as a reminder of Thomas Yates who was an award-winning watchmaker operating from a shop on Friargate until his death in 1890. Other familiar names along this stretch of shops in days long gone included Hamilton's the draper's, Coward Brothers the grocer's and Freeman, Hardy & Willis, who supplied many a Prestonian with a good pair of boots.

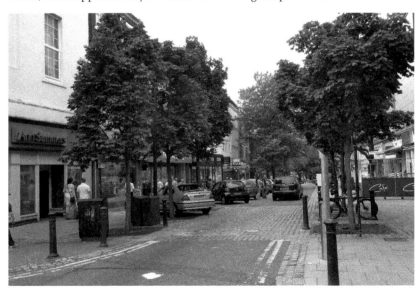

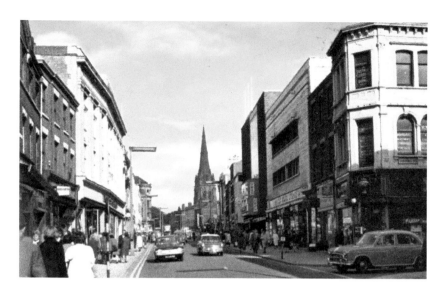

Fishergate Viewed from Guildhall Street

In this picture of Fishergate *c.* 1965 there is plenty of traffic, although by this time it was one way only. On the corner of Guildhall Street a tobacconists was offering a selection of pipes and cigars. Those retail giants Marks & Spencer and British Home Stores were there then, as now, facing each other across the thoroughfare. M&S have been on Fishergate since 1891, although it was only in 1929 that they moved to their present location, whilst BHS opened in 1936, when they took over the premises of Frederick Matthews Ltd. Next to BHS in the earlier image can be seen Owen Owen, situated there from 1937 – and completely transformed in 1959. Further along can be seen the once-familiar clock above the jeweller's shop of H. Samuel. These days George Banks the jeweller trades from the corner of Guildhall Street and the old premises of Owen Owen and H. Samuel are used by other retailers. H. Samuel are now trading just across Fishergate from their former home. Inset – street entertainers abound.

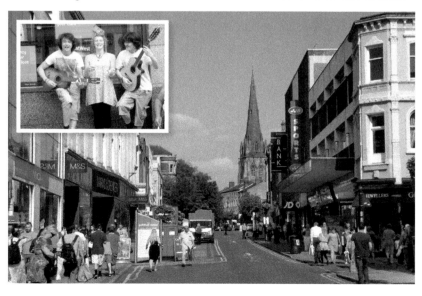

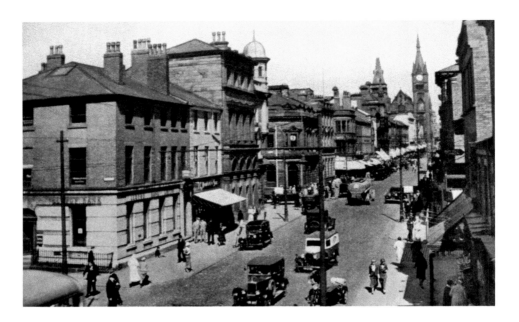

Fishergate Viewed from Fox Street

Sixty years have elapsed between these two pictures. The earlier image *c.* 1952 shows a busy, bustling town centre shopping street. Lloyds bank had taken over the ivy clad Victorian town house on the corner of Fox Street in 1919 – in that image the roof is level with the adjoining property – but now the rebuilt bank is four storeys tall. Prominent on the skyline of the earlier image is the wedge-shaped tower of the old Preston Gas Showrooms – opened in 1877 and knocked down in 1964. The Preston Gas Light Company had begun life in 1815 and, thanks to the efforts of the Revd Joseph Dunn and printer Isaac Wilcockson, Preston became the first provincial town to be lit by gas in 1816. Prominent on today's skyline is the Cubic. And no longer is there a sign pointing down Winckley Square to the Park Hotel overlooking Miller Park.

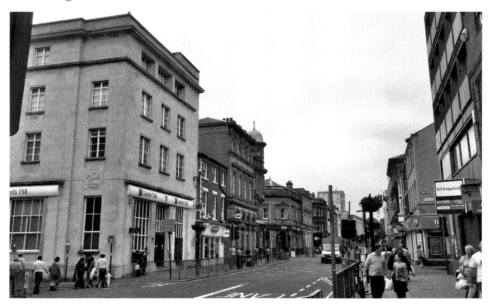

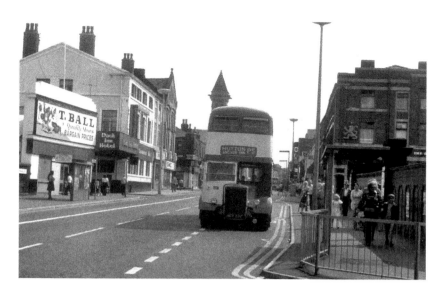

View from Railway Station Bridge Up Fishergate

Only thirty-five years separate these two views, but the scene has changed significantly. Tommy Ball's shoe shop can be seen to the left of the 1976 photograph – a fire destroyed that building in September 1978 when it, along with the adjacent Duck Inn and the Victoria & Station Hotel, was engulfed by flames. Of nineteenth-century origin, the Victoria & Station was a first-class hotel in its day, offering sixty bedrooms and a large ballroom for hire. Happily, the Victoria & Station emerged from its ordeal and is still a popular inn. Alongside it nowadays is a building home to William Hill the bookmakers; alongside that the later Tommy Ball's discount shoe shop, which in recent times was the Sakura Japanese restaurant before emerging, in 2010, as the hair salon of Jo and Cass. To the right, Butler Street has undergone a great transformation with the building of the Fishergate Shopping Centre. The only survivor is the Railway Hotel – the old Queens Buildings of mid-nineteenth-century origin being swept away in 1983, including the Queen's Hotel on the corner that displayed the familiar Red Lion sign.

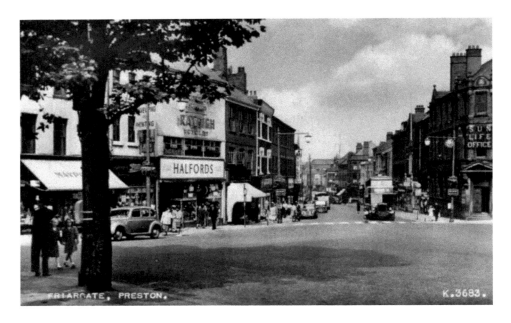

Friargate Viewed from the Market Place

By 1956, when this postcard picture was produced, Friargate was a busy thoroughfare. Up until 1893, the entry to Friargate was very narrow, but the demolition of New Street to the right changed all that. The George Hotel on the corner, built on the site of the old George Music Hall, has had many uses since its hotel days. It had a spell as a Barclay's bank and is currently occupied by the bookmakers William Hill – who would have bet on that! The Tetley's Ale sign on the left is displayed by the once-popular Boar's Head public house, which closed in 1983 to be converted to shop premises. The buildings to the left have all been replaced in the intervening years as the current photograph reflects, but those to the right have simply been transformed. The raised flowerbeds and gates where the zebra crossing was once necessary confirm this part of Friargate is relatively traffic-free today.

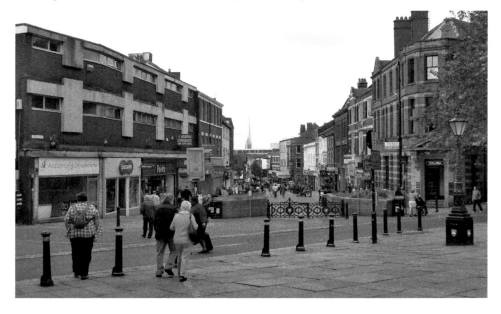

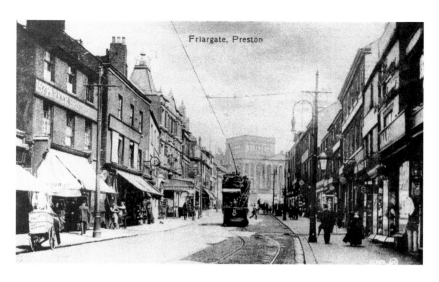

Friargate, Preston

Friargate Looking Towards the Harris Museum

In the earlier photograph *c.* 1906 the draper's stores of Parker Brothers and J. Kay & Sons can be clearly seen in the foreground to the left, whilst the clock just beyond marks the premises of Thomas Yates, the watch and clock maker. Further up is the distinctive canopy of the newly opened Royal Hippodrome, a variety theatre built for W. H. Broadhead & Sons, who were expanding their entertainment empire. It was a magnificent building and a popular place for decades, but eventually dwindling audiences led to the theatre's closure in 1957. It was swept away two years later and a C & A store was built on the site. These days it is a popular Wilkinson's store. As for the properties to the right they all disappeared during a later stage of the development of St George's Shopping Centre in 1999. One of the most familiar buildings along this stretch, positioned opposite the Royal Hippodrome, was the Waterloo Inn, which can be traced back to 1815. Notice of its closure was posted in 1984, and for a while it became a Brittania store. On a recent summer's day, city centre visitors stroll along its length. It is hard to imagine that a century earlier an electric tram and a horse and cart were making their way along the highway.

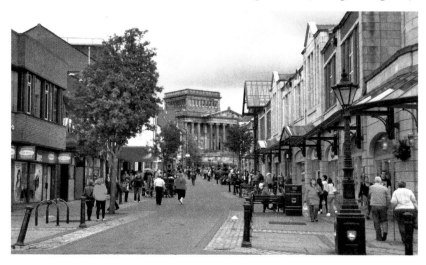

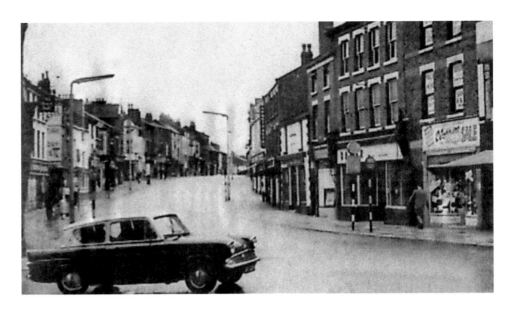

Looking Up Friargate from the Ringway

These images, fifty years apart, depict the scene looking towards Friargate Brow *c.* 1960 and again in 2011. In 1966, the mayor of Preston, Joseph Holden, dug the first shovel-full of rubble to get the inner ring road construction under way. By the time it was finished, the part of Lune Street from which the Ford Anglia is emerging would be swept away. The Old Black Bull would survive the cull, although the premises to its right would be knocked down. In fact, this inn has prospered, having now extended to take over the adjoining property that was the Dallas Inman gallery. Generally, the buildings to the left have survived, including the Dog & Partridge close to Hill Street, although those up to the still-cobbled Union Street, on the right of the photograph, did not. The Old Britannia public house – the two-storey-tall dwelling on the right – of early-nineteenth-century origins was one of those reduced to rubble. They were replaced by a Trident Discount Centre, now a betting shop, and a Queensway furniture/carpet warehouse that became the Grey Friars public house in 1996.

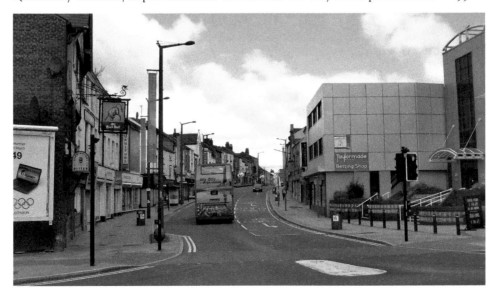

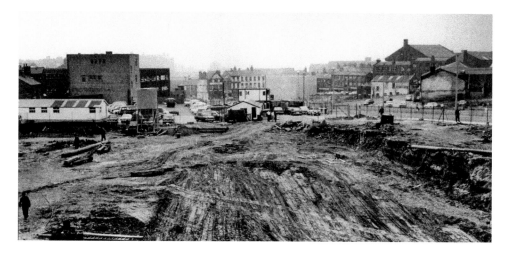

Ringway Development Looking Towards Friargate

Any stranger to Preston who visited the town from 1955 to 1970 could have been excused if he thought a few bombs had been dropped on the place during the Second World War. Fortunately, this was not the case and the almost endless demolition sites were all a part of the necessary slum clearance and regeneration of Preston. The Ringway, which divided opinion when it was developed, is a busy thoroughfare that split Friargate into two. In the picture above, taken a few months after work began on the Ringway construction, Starch House Square, where buses once congregated, has been reduced to rubble and in the distance you can see the Old Black Bull centrally placed with the shops that stood to the left of it demolished. In the 2011 image it is partially obscured by the Grey Friars public house, and to the left is a multi-storey car park, behind which stands the Indoor Market, opened in 1972. The tall building to the left is the Lime House, and to the right is Marshall House.

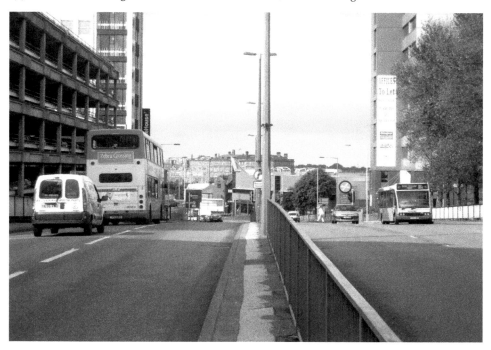

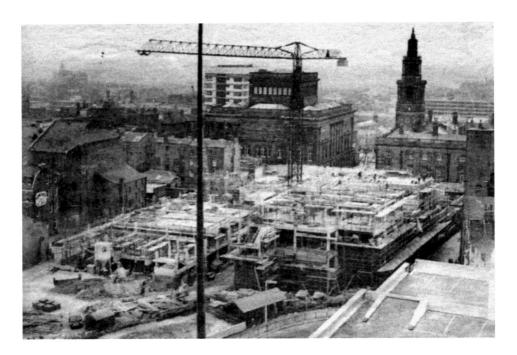

Preston Guild Hall Construction Site, a Rear View

Building of the Guild Hall began back in 1969 and the earlier photograph shows the construction well under way in 1971. A grand opening was planned for the Guild of September 1972, but delays and strikes meant it was unfinished in time. Besides the necessity for the demolition of shops on Lancaster Road and the south side of Lord Street to make way for the building, the old Ribble bus station was also knocked down and it was goodbye to an old familiar stretch of Tithebarn Street. In the recent view, the Harris museum is almost obscured from view, although the tower of the old Sessions House, scene of many a dramatic criminal trial, still dominates the skyline.

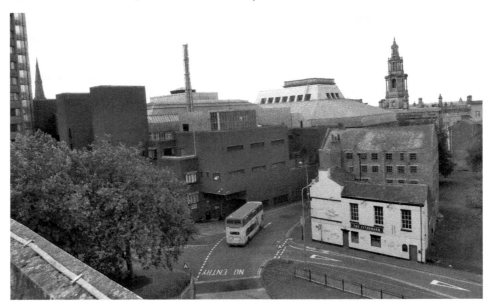

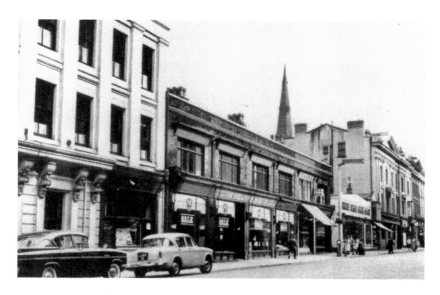

Lancaster Road from Lord Street

The *c.* 1964 photograph shows an everyday scene along the east side of Lancaster Road – the cabinet makers Fryer & Hancock had sale bargains on offer and if you fancied a quick cuppa the Tea Bar was open. In fact the premises from Lord Street up to and including the Ribble Motor office, next to the Stanley Arms, of 1854 origins, were earmarked for destruction within five years as the plans to spend £1.5 million on the erection of a new Guild Hall and Arcade were unveiled. To the left of the Ribble Motor office was Wards End, an ancient passageway that led to the Ribble bus station. Along its length was the Golden Lion public house offering Thwaites Ales. The octagonal Guild Hall building took longer than expected in construction, eventually opening in May 1973. As the recent picture shows, it completely transformed that section of Lancaster Road, and with a 2,000-seat concert hall, a theatre and a shopping arcade beneath, it was a good investment. In the early days, Morrison's had a supermarket within the complex, although now they trade from their Preston Dock location.

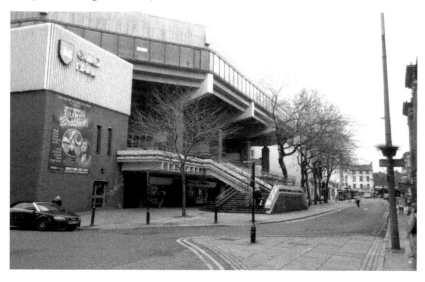

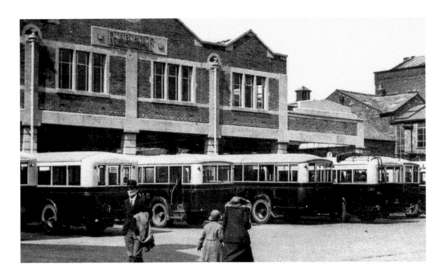

Ribble Bus Station on Tithebarn Street

With the coming of the new Preston bus station the once familiar Ribble bus station site – pictured in its heyday – had to go, the land earmarked for the Guild Hall development. Its memory lingers on, as do the memories of the other bus terminals in Starchhouse Square, Fox Street and around the Miller Arcade. Ribble Motor Services of Preston began in 1919 and operated until 1988 when Stagecoach took them over. From their humble origins with their familiar red livery they became the biggest operator in these parts, with most of their fleet manufactured at Leyland. It is impossible to reflect on today's scene from the same spot, but viewed from Tithebarn Street the rear of the Guild Hall dominates the scene as a Preston Bus makes its way along. There is no indication that Ribble Motors once prospered here and no more the cry of 'tickets please'. As far as Lord Street goes, the old warehouse building stands defiant against the passage of time and the Tithebarn public house still serves beer. At one time no less than four other inns stood on Lord Street, and the Tithebarn carried the name Wagon & Horses until 1969, when it was given a new look and a new name.

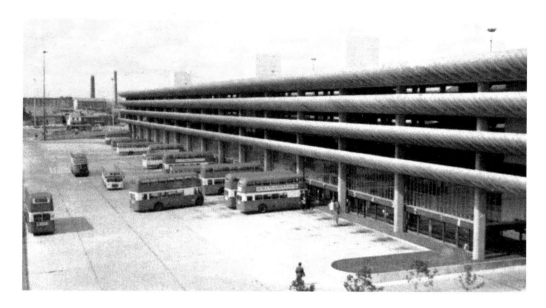

Preston Bus Station, Tithebarn Street

With clearly marked departure and arrival gates, the new Preston bus station was used for the first time by the Preston Corporation fleet of buses on Sunday 12 October 1969. Built on the site of the old fire station and Everton Gardens at a cost of £1 million, with stands for eighty buses and a multi-storey car park, it was designed by the local firm Building Design Partnership. No longer would the buses terminate at various points around the town centre. The opening came with a warning not to walk across the bus apron, but to use the subways. The scene today reflects the busy nature of the place through its lifetime. Sadly, there have been accidents and incidents through passengers using the bus apron to exit the station, and now official walkways have been installed. The future of the award-winning structure is in doubt, with the Tithebarn redevelopment scheme likely to see its destruction.

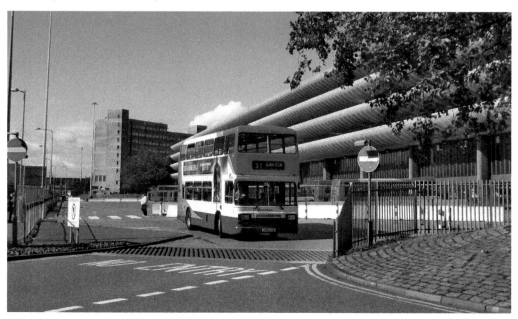

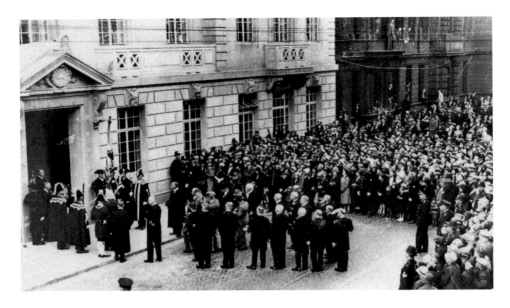

Municipal Buildings on Lancaster Road

There was certain optimism about the future in Preston back in 1931, so much so that the local builder, Thomas Croft, was called upon to prepare a site for the erection of the Municipal Buildings, nestled between the Sessions House and the Earl Street police station. The building, which included a council chamber, was opened in September 1933 and, besides the many dignitaries, a great crowd gathered to witness the official opening, as the above photograph shows. That evening, celebrations went on well into the night, with bands playing and crowds dancing on a floodlit Market Place. Eventually, in 1972, the building officially became the town hall and it is the place where civic matters are conducted. In the present-day image, taken from the balcony of the Guild Hall, the old Earl Street police station can be seen in the distance just before the covered market. It was opened in May 1858, having cost £3,000 to erect, and was home to the Preston Borough Police until 1973.

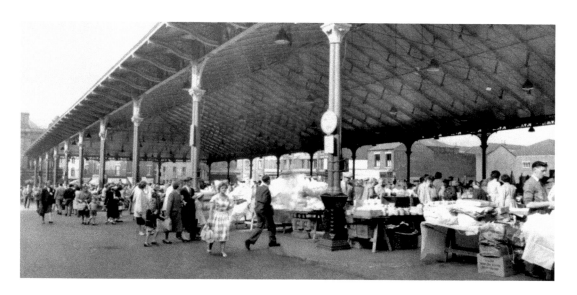

Preston's Covered Market Viewed from Lancaster Road

Land formerly known as 'the Orchard', where cows grazed amongst the trees, was selected for the construction of the market. It turned out to be a protracted affair. The contract was originally given to Joseph Clayton of the Soho Foundry, and during construction the roof collapsed in August 1870, leaving a tangled mass of ironwork. The work was finally completed in 1875 after William Allsup stepped forward to complete the task in reward for £9,126. The Preston folk were brought up on market trading as the 1961 image above suggests, with happy families busily shopping. At the far side you can glimpse Liverpool Street, where the Orchard Methodists chapel, which closed down in 1954, once stood. Allsup's work has certainly stood the test of time and the Covered Market still stands, as the modern picture testifies. Although uninviting on a wet and windy day, the hardy traders still endure and sell their wares. The traditional market stalls are on display four days a week, although food can only be bought within the Market Hall. With its main entrance on Liverpool Street, it cost £1 million to build and opened in October 1972, bringing a new era to market day shopping, including a wing exclusively for the fishmongers of the town who left their outdoor Fish Market behind.

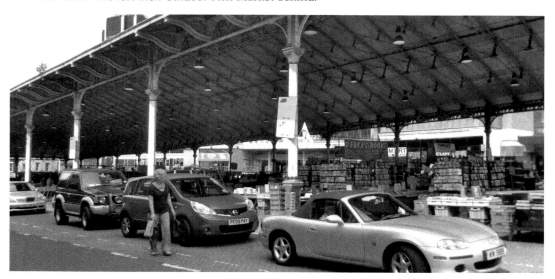

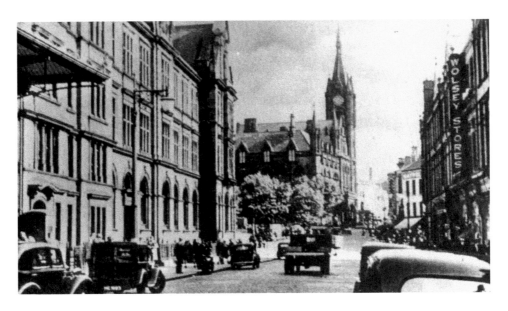

Market Street Viewed from the Covered Market

The thing about Market Street is that it takes you from the Market Place to the Covered Market – so it is aptly named. It is probably most famous for the row of red telephone boxes alongside the old Central Post Office building, now called Deans Court Chambers, and the red Victorian post-box on the corner of Friargate. In the *c.* 1935 image there is only one telephone box in the left-hand corner, but now there are nine. In this age of mobile phones we have done well to preserve them. In the earlier image, the old Gothic town hall can be clearly seen along with the Maypole store sign on Cheapside. In the recent photograph below the Cubic occupies the town hall site. Inset – all in a row, the well-preserved telephone kiosks.

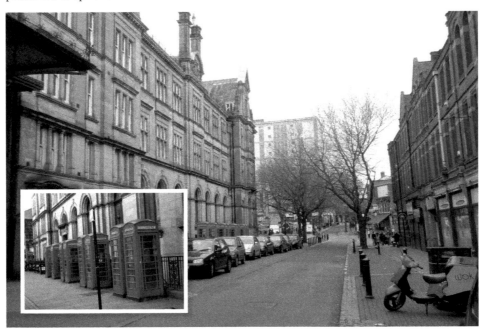

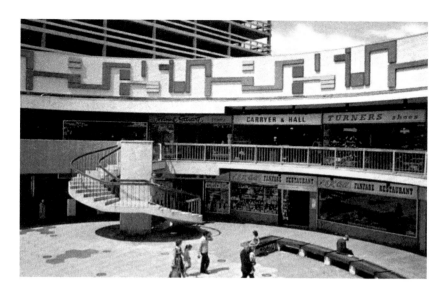

St George's Shopping Centre

Situated between the main throughfares of Fishergate and Friargate the shopping centre was built on the area known as Bamber's Yard, with origins back to 1827, where a number of shopkeepers had run thriving businesses amidst the tangle of alleyways until its demolition in 1963. St George's opened for business in November 1964 with about thirty of the planned 120 units welcoming customers who climbed the spiral staircase to the upper floor. Said to have cost over £5 million to construct, it was officially opened by Mayor Alderman William Beckett in March 1966 – by which time it was a thriving concern. The centre had a roof added in 1981 when it was refurbished, and in 1999 it was completely transformed once more and, standing three levels high, it carried the name the Mall. Ownership changed hands again in 2010 for £87 million and it reverted to its original name. With entrances from Fishergate, Friargate and Lune Street, it is home to a number of leading high street retailers and remains a popular shopping area.

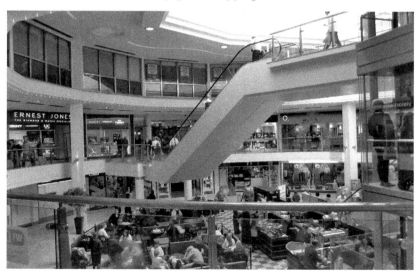

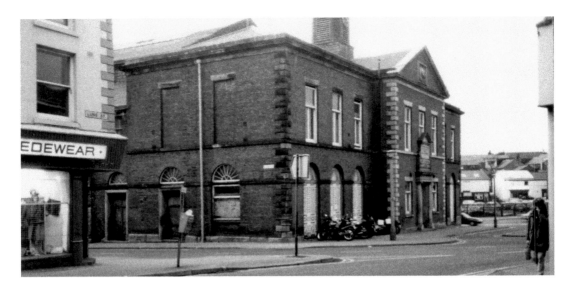

The Assembly on Lune Street

This building is without doubt one of the most remembered buildings in Preston. Older folk will recall it during the years of decline, as in this photograph *c.* 1987, before the rear portion was swept away in 1989. Likewise, the memory of those great events that had taken place here still linger. It was actually opened in 1824 as the Corn Exchange and it served many purposes including hosting local fairs and markets. During 1881/82 it was much altered and transformed into the Public Hall, a place for large public gatherings and musical entertainment. 3,500 people could be accommodated within. The Preston Corporation planned to spend £7,000 on the upgrade, but in the end spent upwards of £16,000. Great speakers, great musicians and significant events have marked its history. Local builders Conlon were involved in the excellent renovation of the front portion and now it is a popular public house called The Assembly. With the statue of the Lune Street Riot of August 1842 at the front, it remains a focal point and a place for gatherings.

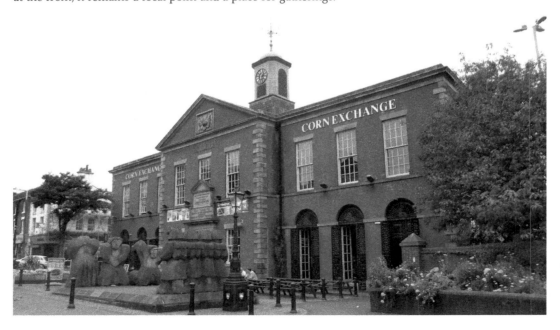

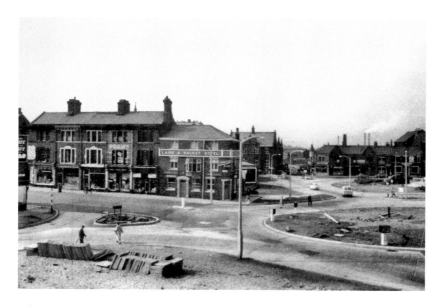

Fylde Street Roundabout Viewed from Walker Street

The earlier image *c.* 1962 shows construction work proceeding on the roundabout where Friargate, Walker Street, Adelphi Street, Fylde Road and Corporation Street all converge. In the distance to the right can be seen the properties along Kendal Street, soon to be knocked down, including the original Fylde Tavern and the Star Cinema. On the skyline, smoke billows from the chimneys of Penwortham power station. In both photographs the Lamb & Packet Hotel holds pride of place at the bottom of Friargate. It derives its name from the Lamb in the coat of arms of Preston and from the days when the packet boat service ran along the nearby canal. Back in 1822 the Preston Botanical Society met regularly within the inn. The adjoining terrace of shops remains in business, although the goods on offer have changed significantly.

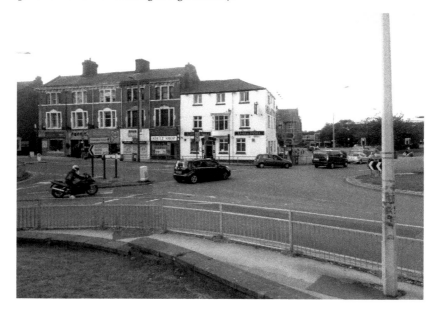

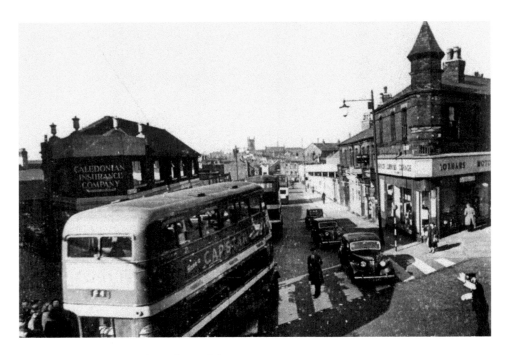

Corporation Street Looking from Fishergate

This street stretching from Fishergate to the Fylde Street roundabout remains a significant highway for traffic despite being split in two by the Ringway. In the image *c.* 1958 it is rush hour as a policeman on point duty halts the flow of traffic while a bus advertising Capstan cigarettes turns off Fishergate. The old Victoria Buildings on the right, which were home to Loxhams Motors, have been replaced, although the old Caledonian Insurance building remains with different tenants. These days, traffic lights control the junction and the zebra crossing is long gone. In the distance on the right is the newly built Premier Inn, which opened in March 2011 having cost £23 million to construct.

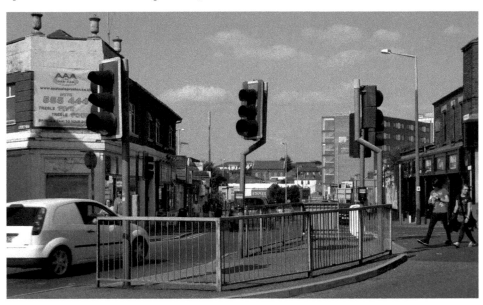

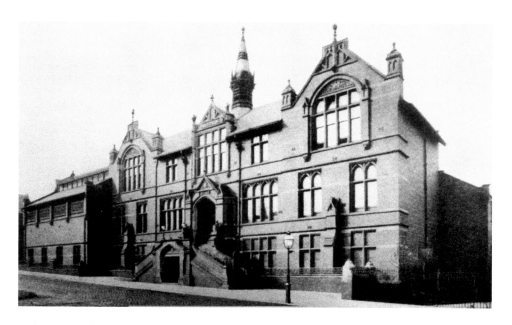

University Of Central Lancashire, Corporation Street

Preston was rightly proud in late Victorian days when the new Harris Institute Technical College was erected on Corporation Street. It had been funded thanks to the generosity of the late Edmund Robert Harris, and was officially opened by the Earl of Derby in 1899. The roots of this educational establishment go back to the old 'Institution for the Diffusion of Knowledge'. Little could one have imagined back then that this building, with the Lancaster Canal at its rear, would be the heart of a sprawling university complex that has devoured much of the land around it in the intervening years. Following its days as the Harris College it became the Preston Polytechnic in 1973, then the Lancashire Polytechnic in 1984, before taking the grand title of University of Central Lancashire in 1992. In a comparison of the two photographs looking up Corporation Street from 1897, and today the extension of that building alone is apparent.

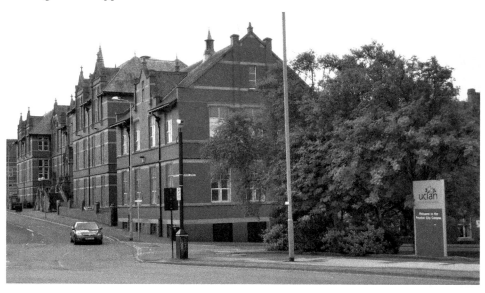

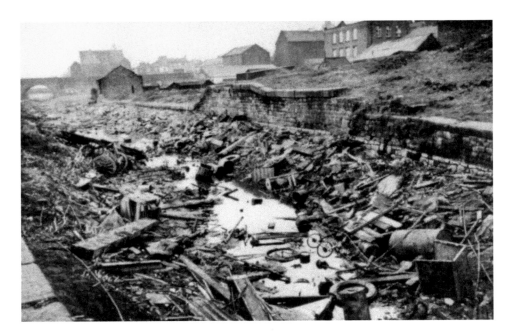

Site of the Lancaster Canal at Maudland

It is hard to imagine nowadays that the Lancaster Canal, which terminates at Tulketh Brow, used to terminate at the rear of the old Corn Exchange in the heart of the town. It is possible to a certain extent to trace the line of the canal these days although the growth of the UCLAN campus makes it difficult. The earlier image *c.* 1959 shows the drained canal looking towards Maudland Road, beneath which the canal flowed. As the above picture shows that stretch of canal had become a dumping ground for all manner of things – any old iron, indeed! In the latest photograph the canal bridge looks extremely well preserved fifty years on, but now the latest UCLAN buildings stand where canal boats once sailed along.

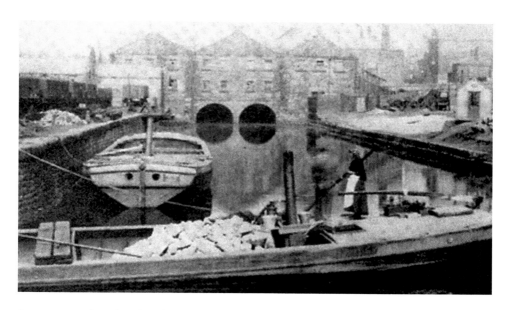

Preston Canal Basin, Fleet/Wharf Street

In 1798, canal communication between Preston and Tewitfield by way of Lancaster was established, being extended to Kendal in 1833. During the Preston Guild of 1822, a packet boat went twice daily to Lancaster. Those days of pleasure boat travel were most inviting for those not in a hurry. The earlier photograph above, c. 1896, shows the row of warehouse buildings, behind which is the rear of the Public Hall. The canal, noted for its carrying of coal and limestone, was by this time being overtaken by the railway for transporting goods. After the Second World War, the basin was gradually filled in and a Dutton Forshaw car salesroom was built facing Corporation Street. In the photograph of 2011 there is no trace of those canal days or Dutton Forshaws and a shopping centre complete with Aldi store and car park occupies the site. To the right on the skyline can be seen the cupola of the old Public Hall and the tower of the Sessions House.

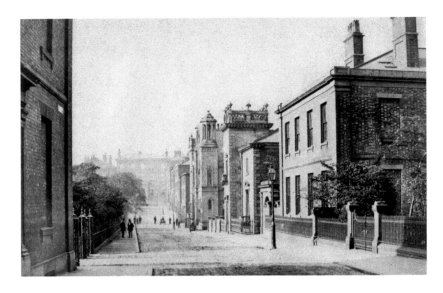

Winckley Square Looking from South-East Corner

Just a few short strides from Fishergate is the delightful Winckley Square. William Cross, inspired by his time in London on legal studies, resolved upon his return to build houses around a square as was commonplace in the capital city. In 1799 he erected the first one at the south-east corner of Winckley Street. The land was bought from Thomas Winckley and was part of a meadow known as the Town End Field. The stipulation was that all the houses would be three storeys high and uniform in appearance. There were to be no factories, no warehouses or shops and certainly no public houses. The scene from the south-east corner has changed dramatically in the 150 years separating these photographs. Cotton manufacturer William Ainsworth's Italian-style villa, which stood at the corner of Cross Street has now gone, so too have the Literary & Philosophical and Winckley Club buildings. The former residence of Alderman Thomas Miller can be seen in both photographs at the top of the square.

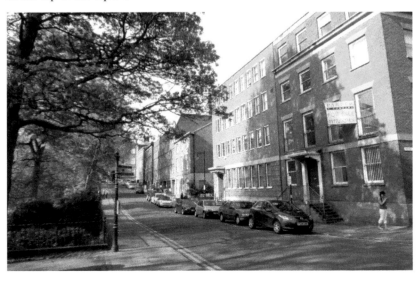

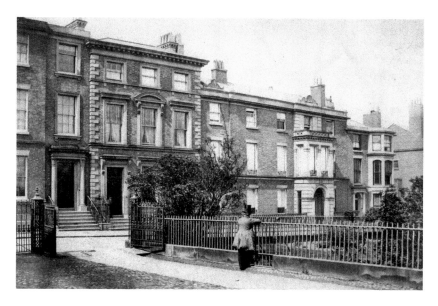

Winckley Square Looking from the South-West Corner

Nowadays, the square's once-private gardens are an open public park and a tranquil place to eat your lunch on a summer's day. It was, in the nineteenth century, home to many prominent townsfolk, such as Richard Newsham, Thomas Miller, William Ainsworth and Thomas Batty Addison. In 1863, the Victorian photographer Robert Pateson captured the peaceful setting with a top-hatted gentleman in the foreground. Along this side of the Square, past Garden Street, residents in late Victorian times included suffragette Edith Rigby who in 1893, married Dr Charles Rigby and their home was No. 28. Nextdoor at No. 27 lived Sir Robert Charles Brown, the notable Preston physician. Following his death in 1925, the property was sold at auction to Preston Catholic College for £4,550. During its long history, the square has been a significant place for education, with Preston Catholic College, Winckley Square Convent, Preston Park School and Preston Grammar School all educating townsfolk here. In the recent photograph the buildings have altered little, whilst the greenery has flourished.

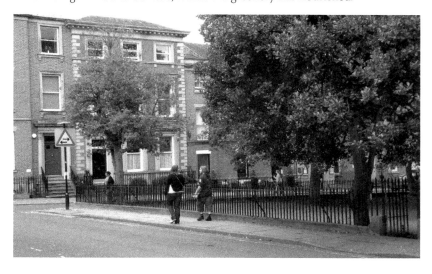

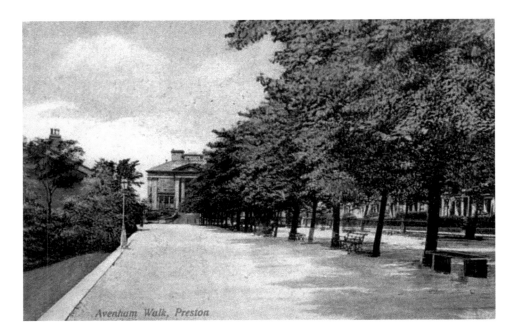

Avenham Walk, Preston

Avenham Walk, Ribblesdale Place

Apparently as long ago as 1697, the Corporation of Preston made plans to create this walk and, for a sum of £15 out of the town's revenue, they purchased the land and decreed that it be planted with trees and made into a gravel walk, to be done as cheaply as possible. The earlier Edwardian postcard view reflects the beauty of the place with rows of maturing limes down the centre and to the right of the picture. Even by this time some earlier trees had decayed and been replaced, but the beauty of the leafy walk had been maintained. At the top of the walk the Harris Institute can be seen, built 1846–49 in Greek/Italian style to the design of John Welch, costing around £6,000 to construct. In the photograph taken on a sunny summer evening in 2011, the steps to the old Institute building can just be glimpsed beyond the green foliage, and the tranquillity of the surroundings remains a source of pleasure.

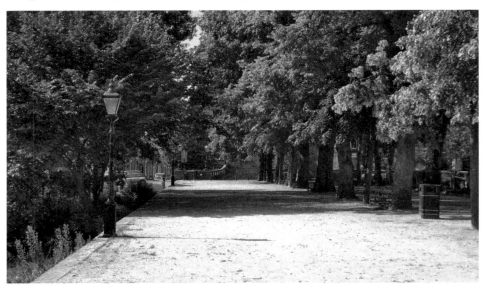

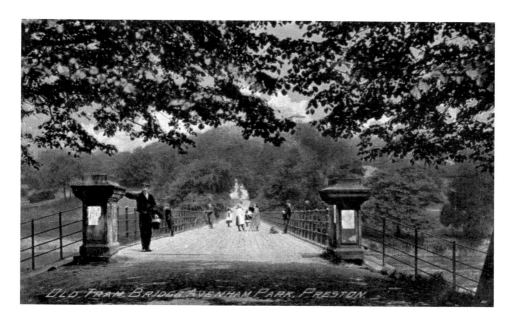

The Old Tram Bridge

In its idyllic setting the Tram Bridge over the River Ribble is a familiar landmark to local folk. These photographs, a century apart, display the same serenity in the setting. The bridge owes its origins to the days when a link was required between the old canal at Walton Summit and the Lancaster Canal that flowed from just beyond the Corn Exchange to the north. The bridge was used until 1859 to carry a tramway that conveyed coal between the two canals and the wagons were hauled up the steep Avenham incline by steam power from an engine house. The original rickety wooden structure of 1802 construction was given a structural overhaul in 1902, and in 1936 it needed running repairs after flood water debris damaged supports. During the Second World War, the timber decking was removed to thwart any German invasion advances. In 1966, it was lovingly restored by Preston Corporation with concrete replacing the worn timbers.

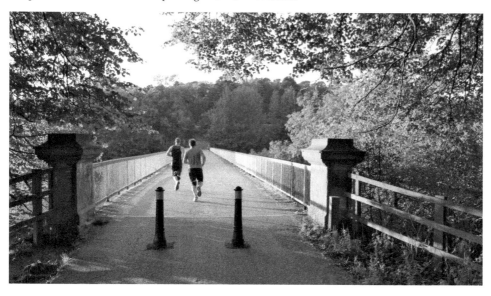

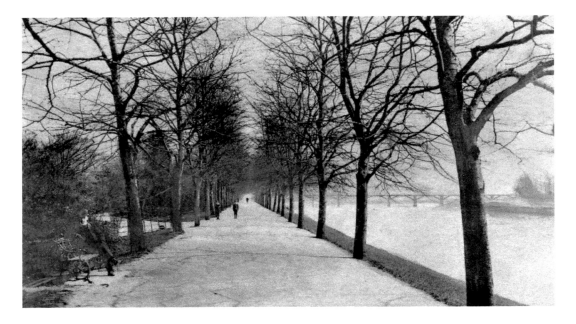

Riverside Walk, Avenham Park

There are few greater pleasures than walking beneath an avenue of trees by the side of a river. Historian Anthony Hewitson wrote of this walk in 1883, remarking, 'the walk on the southern side, near the river, is planted with lime trees to form an avenue. Some of the largest are, at the present time, from 24 to 30 inches in girth at one foot from the ground. Those nearest the East Lancashire Railway Bridge have just begun to meet overhead, and they form a beautiful, leafy canopy. The trees constituting this avenue were planted in 1864. We have cherished and nurtured this avenue of limes and in the earlier and latest photographs captured the scene is a joy to behold. In both photographs, to the right, the Tram Bridge can be seen in the distance spanning the River Ribble.

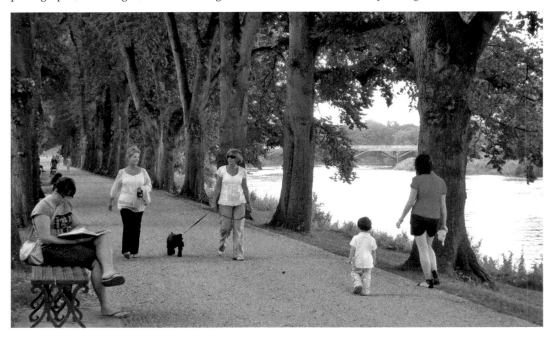

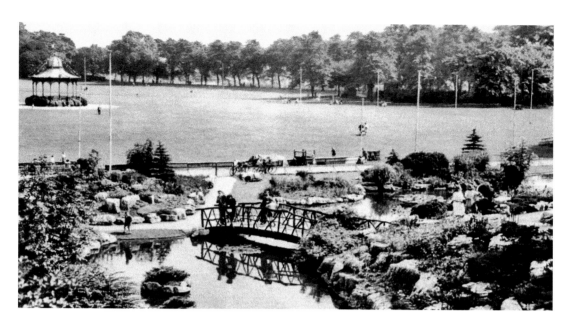

Japanese Gardens, Avenham Park

These gardens were official opened in November 1936 by Alderman James Harrison of the local bakery firm, Mayor of Preston at the time. The earlier image *c.* 1953 shows the garden well established and in the background to the left can be seen the original bandstand, the scene of many a rousing concert. Pictured again in 2011, the gardens have just undergone a remarkable renovation and been returned to their former glory with the wooden trellis bridge still a popular place to pause, and see your reflection in the water.

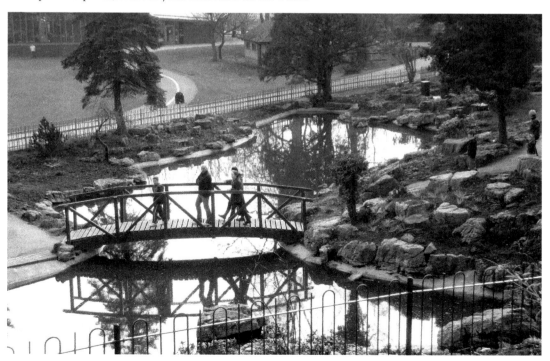

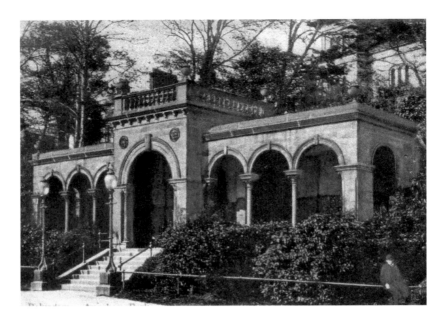

The Belvedere, Avenham Park

The Belvedere stands on Avenham Park where the old, stationary steam engine stood, which was used to haul loaded coal wagons up the steep incline from the Tram Bridge. It only arrived here after being removed from Miller Park, so that Lord Derby's statue could be placed in its prominent position there. The Belvedere was first erected in 1866 and cost £468. Much restoration work has been carried out upon it and its gates are usually shut. There are exceptions though and such an occasion occurred in 2008, when an unusual visitor arrived in the shape of the Lion King. A production of *The Chronicles of Narnia* took place around the park, as seen in the image below.

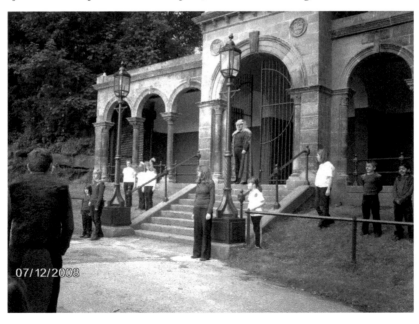

07/12/2008

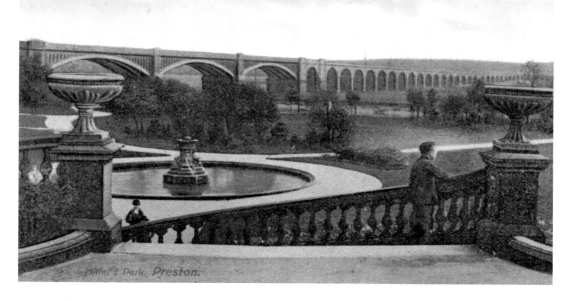

Miller Park Looking from Above Lord's Walk

This postcard view of Miller Park was no doubt sent by many an Edwardian who had enjoyed the view looking towards the River Ribble. Particularly impressive looking at this time was the East Lancashire Railway Bridge over the River Ribble. This bridge originally had fifty-three brick arches on view across the river, as can be seen on the earlier view. Alas, the foundations were weak so the arches were filled in to leave only the embankment on view. In the view of 2011, the fountain continues to delight and the bridge still stands. No railway signals are required now, the old Preston to Southport route falling victim to the Beeching plan, with closure announced in 1964. You can still climb the steep stone steps from Avenham Park and walk along the bridge to take an elevated view of the pleasant surroundings.

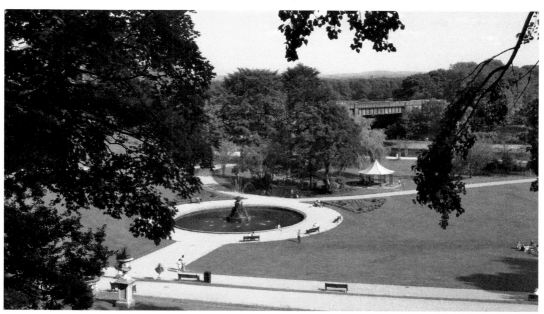

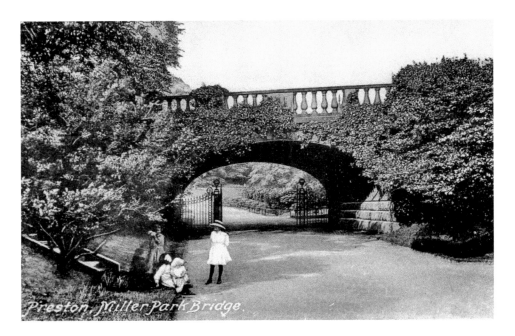

Ivy Bridge Looking from Miller Park

This bridge, which once carried the East Lancashire Railway, still divides the Miller & Avenham parks and the railway track is now a cycleway. Both parks benefited from the dark days of the cotton famine that began in 1861 and led to idle hands from the mills and factories being employed in laying out the two parks. Following recent restoration work, the Broad Walk or Ivy Bridge has now been shorn of ivy and the wrought-iron gates have been restored. The current Preston folk, just like the Edwardians, can still pass beneath it.

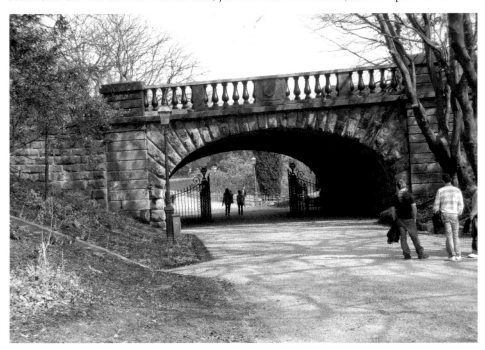

South Africa – Boer War Memorial on Avenham Park

On 6 October 1904, the obelisk dedicated to the soldiers of the Loyal North Lancashire Regiment, who had served in South Africa, was unveiled in the Market Place. A great crowd gathered and paid due respect to the memory of the eighty-six who had paid with their lives. It stands 25 feet tall and in February each year a Kimberley Parade takes place in memory of the 1st Battalion of the LNLR and their heroic defence of the town of Kimberley against the Boers. Nowadays, the monument stands in pleasant surroundings on Avenham Park. It was removed there in 1925 to make way for the erection of the Cenotaph at the front of the Central Post Office building. That monument serves as a reminder of the 2,000 soldiers of Preston killed in the First World War. To the side of the Boer War Memorial can be seen the Swiss Chalet which predates much of the park. It was built in 1850 by John Tomlinson. Generations have sheltered from the rain here and enjoyed splendid views of Avenham Park.

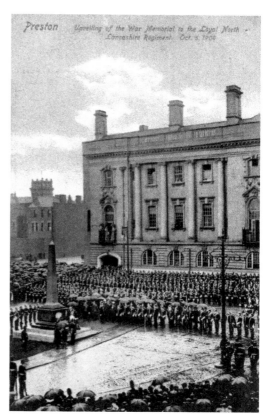

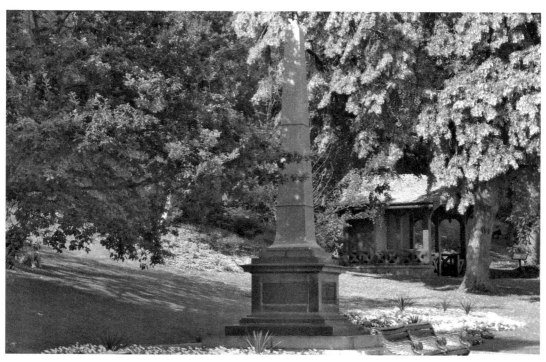

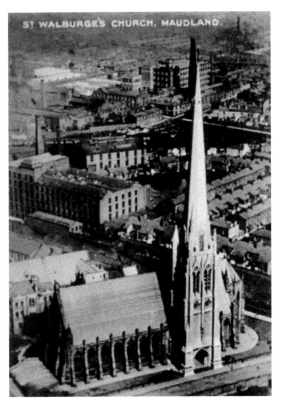

St Walburge's Church, Maudland.

St Walburge's Roman Catholic Church, Maudland

This Gothic-design church has been at the heart of the Roman Catholic community in Preston since it was built during the period 1850–54 to the design of Joseph Hansom – of Hansom cab fame. No less than four bishops attended the opening ceremony in August 1854 – no doubt keen to see that the £15,000 investment had been well spent. By 1867, both the tower and the landmark spire of limestone had been completed, reaching 314ft 6in into the sky. As long ago as 1293, a leper hospital dedicated to Mary Magdelan had been in the Maudland area, and Franciscan monks were familiar inhabitants of the town. The early image shows a backdrop of cotton mills, factories and terraced homes from where the Catholics flocked to divine worship – in the early days inspired by Father Thomas Weston, who was the driving force behind the building of the church and who died in November 1867.

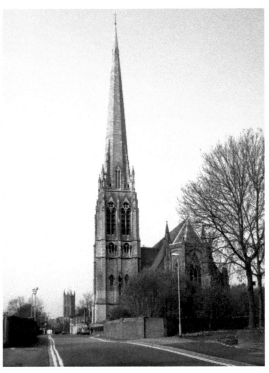

St Walburge's Viewed from Peddar Street

The nearby street from which the church is entered carries the name of Weston Street to commemorate Father Weston and his great contribution. At the time of his death, hourly masses from 8 a.m. to 11 a.m. each Sunday attracted a total congregation of over 3,000 worshippers. To maintain a building of such grandeur is no mean task and, viewed from Peddar Street in the recent image, both church and spire remain a glorious sight, with the 15ft-tall cross aloft of the spire. Like many other local churches it has, in more recent history, fallen on hard times, but so far managed to survive. Yes, the weather vane had to be removed after being struck by lightning, yes the spire has needed tender care from the likes of steeplejack Fred Dibnah; yes, the Talbot School buildings were demolished twenty years ago, and the church had to be closed for a period whilst dry rot was cured, but it survived all.

St Augustine's Roman Catholic Church, Avenham

Built between 1838 and 1840, this church originally cost £5,000 to construct. In 1890, the church was lengthened and the two towers – 70ft tall – were added. So followed a glorious period in the church's history, pews packed with devoted Catholics and four or five priests stationed there. One of the great features of the church was the absence of pillars, so that a great view of the altar could be had by all. Unfortunately, in 1984 dry rot was discovered in the roof and the church was closed and services moved to the nearby school, from where the church still operates. All were keen to preserve the building, but in 2004 the main body of the church was demolished whilst preserving the iconic entrance and the towers. A purpose-built leisure and sports centre was then added and the building is now part of the Cardinal Newman College. The later image captured by Anne Foley shows the demolition underway. Inset – Father Peter Foulkes waits at the altar to welcome the bride at a 1971 wedding.

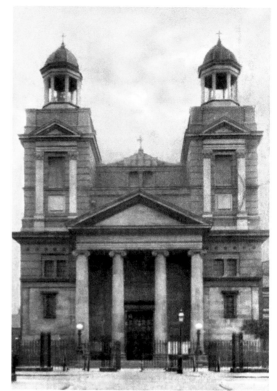

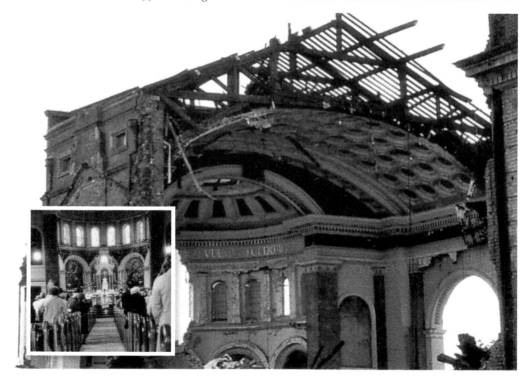

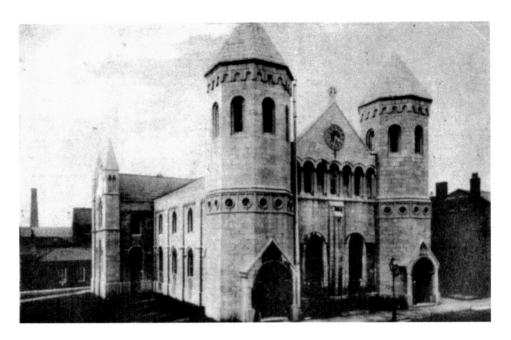

Christ Church Viewed from Fishergate Hill

The limestone construction of Christ Church, in the Norman architectural style, on Bow Lane was consecrated in 1836. It was paid for by public subscriptions of £3,000 and its construction was watched over by Roger Carus Wilson, the Vicar of Preston from 1817–39. It was part of a building programme that would leave the town with twenty Church of England churches by the early twentieth century. Alas, the church was closed in 1970, and a dual-purpose building was constructed on the site by Lancashire County Council. Thankfully, the limestone towers remain. Visible through the gates from Fishergate Hill it is at the rear of County Hall, which was opened in 1882.

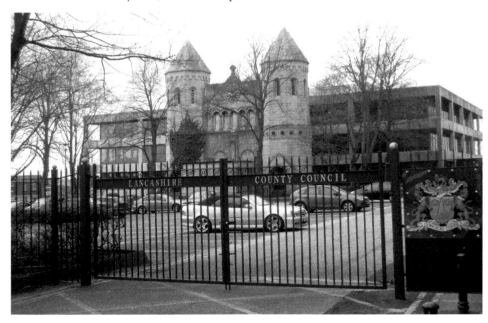

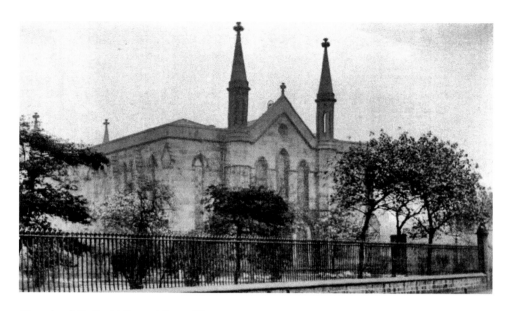

Church of St Paul Viewed from Ringway

The foundation stone of St Paul's was laid in October 1823; it cost £6,500 to build and was opened three years later. Made entirely of stone, it was described as elegant in appearance and was large enough to accommodate a congregation of 1,200. With a Sunday attendance of over 800 it was a flourishing parish in mid-Victorian days and their choir became most popular. The graveyard within the stone boundary walls was the final resting place of over 6,500 folk – the last burial taking place in 1855. Like so many churches it had a dwindling congregation and in 1973 the doors were closed and the parish amalgamated with St Jude's. Eventually, after eight years of neglect it was taken over by Red Rose Radio, and is now home to Rock FM – so let the music live on. This latest image taken from the top of the Preston bus station shows the church in its modern-day setting.

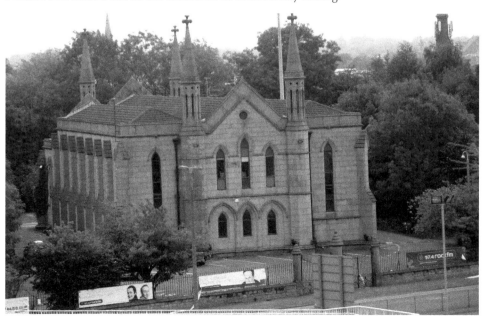

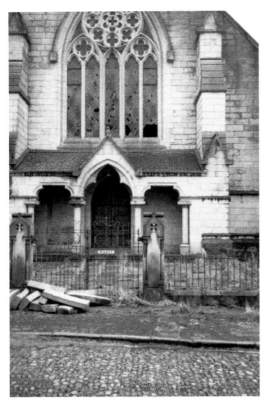

St Mark's Church, Wellington Street

If you glance at the first image you could be forgiven for thinking that the end was nigh for a church constructed at a time when the town was in the midst of the cotton famine. Of the crucifixion form in design, it cost £7,000 to erect between 1862 and 1865 and thanks to a Bairstow legacy of £1,000 the magnificent tower, complete with six fine-toned bells, was added by 1870. In those Victorian days the church had a regular congregation of over 600 strong, with enough space for 1,000 on high days and holidays. A declining congregation and the necessity for considerable maintenance and repair work led to its closure in 1983. After a decade of neglect and exposure to extremes of weather, work on the restoration of the church building was undertaken with apartments planned. It was a protracted task with 'Flats for Sale' banners flying from the tower, but eventually restoration was completed and it became home to a modern generation. Captured on camera recently, its exterior is a joy to behold and would have the approval of the Revd T. Clark, the man who strove to see it created.

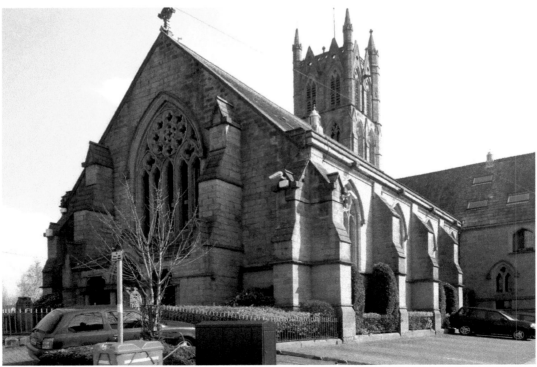

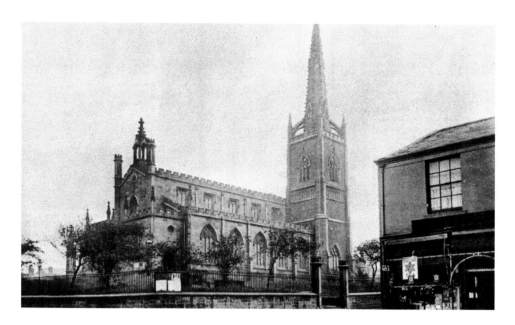

Church of St Peter Viewed from Fylde Road

The foundation stone of St Peter's church was laid in Guild Week 1822 and eventually, at a cost of £7,000, the Gothic structure was completed in 1825 surrounded by open fields. This church, pictured above *c.* 1904, began to benefit from the building-up of the Adelphi area and in 1852 the tower and the spire were added – paid for with a £1,000 bequest from Thomas German, former mill owner and Mayor of Preston. Several members of the Temperance Movement are buried here, including Richard 'Dicky' Turner who was credited with being the first to utter the word 'teetotal'. The latest image clearly shows that changes have occurred since it was closed as a church in 1973 and became the St Peter's Art Centre – within the UCLAN concourse. University buildings have encroached on the old graveyard area to the left, and, at the right at the rear of the church, can be seen the impressive University Library.

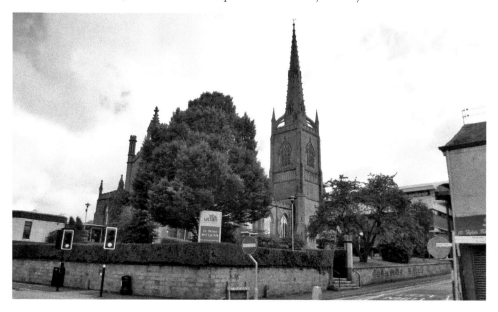

St Ignatius Roman Catholic Church Looking from Meadow Street

Back in 1833, the Jesuit Fathers built this much-admired church. It was a welcome addition to serve a growing Roman Catholic flock. The black and white image records the awful day in late July 1911 when the beloved Father Herbert Butterfield was knocked off his bicycle and killed whilst returning from Stonyhurst, where he had been attending a funeral. His funeral on the following Tuesday saw the church filled to the rafters. An eloquent preacher, aged just forty-nine when killed, he was deeply mourned. In the image of today you can see the war memorial placed there after the First World War, during which no less than 224 men of the parish perished. It is a church steeped in tradition and the great Preston poet Francis Thompson was amongst those baptised here.

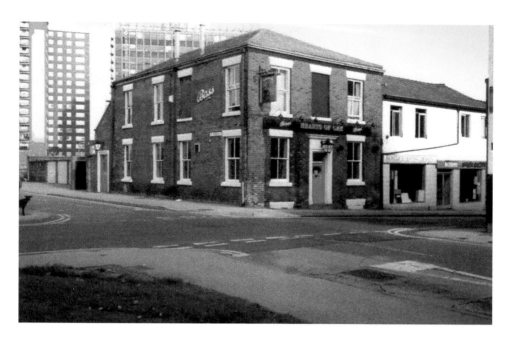

View from Adelphi Looking Along St Peter Street

Only some twenty years separate these two photographs, yet things have certainly changed in this corner of Preston. The public house on the corner looks good for a structure over 150 years old. It carried the name Hearts of Oak until recent times, and is now the Variety. The lock-up garages in the earlier image of 1990 were once the site of the Cosy Cinema; opened there in 1921 in a converted chapel. For a youngster, admission was one penny or an empty jam jar. Standing tall at the rear of the public house is the British Telecom building. Missing from the recent view is one of the equally tall blocks of flats on Moor Lane. They were demolished in May 2005 after a troubled history and in their place are now a number of apartment blocks.

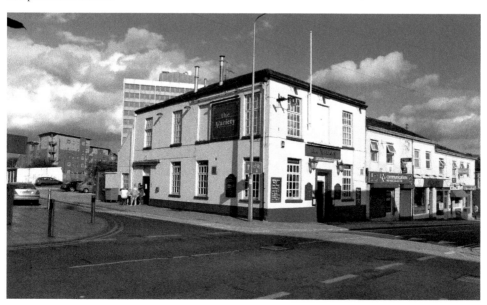

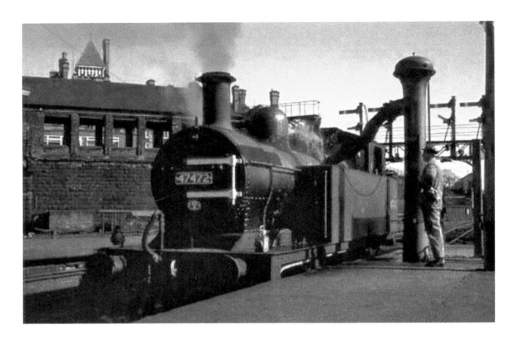

47472 What Became of You?

Many a post-war youngster in Preston took up the hobby of trainspotting and would spend hours at various vantage points with their pocket book copy of an Ian Allan guide to locomotives. Consequently, some of the hard-worked steam engines based at the Preston locomotive shed would become familiar. Such an engine was No. 47472 – never deemed worthy of a name, it was nonetheless a sight to behold. Pictured here in 1966 taking water on board, in the background is the Park Hotel. If you were one of those local railway enthusiasts then no doubt from time to time the number will have flashed through your mind. Nowadays, much to my surprise, the number takes pride of place on the corner of the Market Place when Norman Roberts decorates his hot potato and parched pea stall.

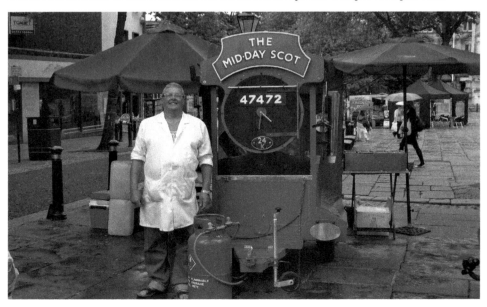

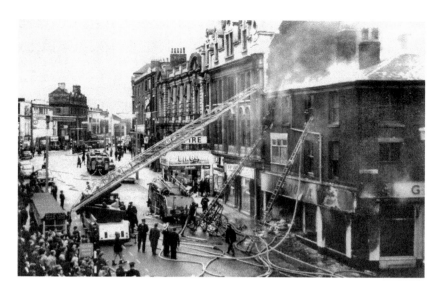

Calling Out the Fire Brigade

In the days before the St George's and Debenhams shopping centres, Church Street was a thriving shopping area in the town. One of the most notable shops was Gooby's, the outfitter's store on the corner of Tithebarn Street, a place ladies flocked to buy exclusive fashions. As can be seen in the photograph above, all that was to end on 12 March 1965 when a fire broke out, leaving the store a burnt out ruin. The blaze was so fierce it took fifty firemen to bring it under control and nearby buildings were evacuated. A crowd of over 2,000 witnessed the scene, including many from the Empire bingo hall and the Palladium cinema where performances had been halted. On this occasion when the alarm was raised the fire brigade had to journey from Blackpool Road, which they did in pretty quick time, yet three years earlier the fire station had been just around the corner in Tithebarn Street. In the present-day photograph below, the immediate scene is barely recognisable, although on the skyline there are familiar landmarks.

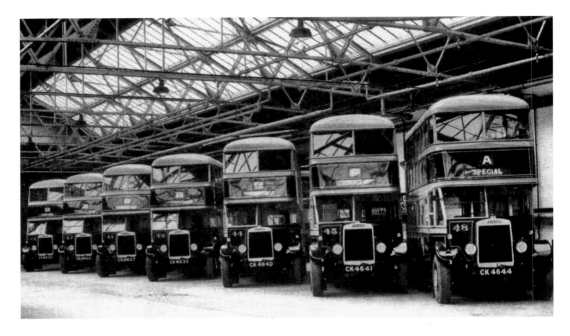

Preston Bus Depot – Deepdale Road

A line-up of gleaming buses belonging to Preston Corporation *c.* 1932 at the depot on Deepdale Road, which was constructed in 1904. The days of the trams were numbered and the double-decker buses, complete with driver and conductor collecting the fares, were about to take over. Today, a colourful collection of over 120 buses of various sizes operate out of Preston Bus station. The conductors are no longer required, but the buses are stabled in the same depot from where trams used to operate. Inset – A present-day view of the bus depot from Deepdale Road.

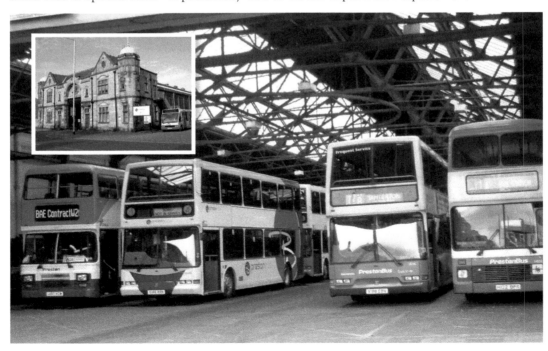

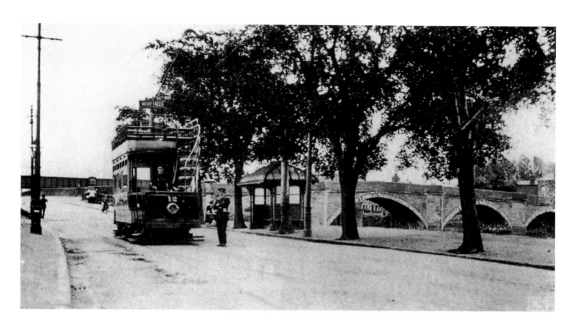

Last Stop Broadgate

In the earlier photograph, the year is 1906 and it is destination Withy Trees for the Preston Corporation tram built by Dick Kerr's at their Strand Road factory. The elaborate cast-iron waiting shelter has now been replaced by a modern bus shelter. In the background of the earlier photograph, to the left, is the West Lancashire railway line that terminated at the Fishergate Hill station. The Penwortham old bridge that spans the River Ribble dates back to 1759 and is a popular route for cyclists and pedestrians these days. In the 2011 image, the tram lines are gone and a Preston bus arrives to collect passengers for the journey into the city. Inset – The old Fishergate Hill railway station, once a familiar sight.

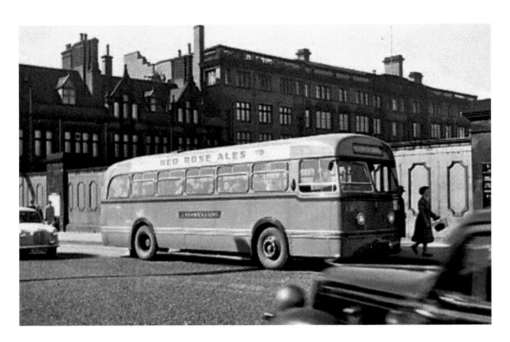

Fishwick Buses on Fishergate Railway Bridge

A Leyland Olympic operated by Fishwick Bus, advertising Red Rose Ales stops on the Fishergate railway bridge to a background of the County Hall, *c.* 1956. John Fishwick moved from Wales to Leyland in 1907 and he bought a steam-propelled wagon to get into the haulage business. Within three years he was carrying his first passengers after converting his petrol-powered second vehicle to transport customers to Preston at weekends. Since that time they have continued to be a familiar sight in Preston and are an independent operator. In times past they could be seen in Starch House Square or on the old Fox Street bus terminus. Once again in 2011, a J. Fishwick & Sons bus halts on Fishergate.

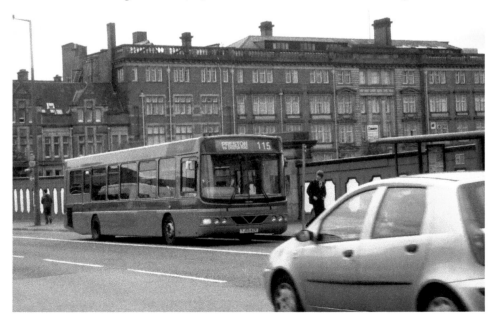

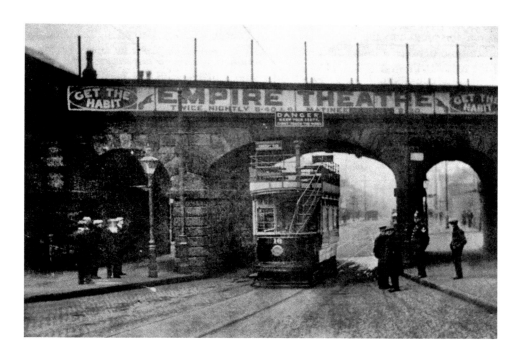

Fylde Road Railway Bridge

With the coming of the railways, the building of bridges became commonplace in Preston. This one on Fylde Road was built to accommodate the railway linking Lancaster – opened in 1840 – and carries the lines heading north. The road by necessity narrows here and, as the *c.* 1913 image shows, the central arch was just tall enough to permit the electric tram on the Ashton route to pass beneath its arch, to the relief of the onlookers. The sign over the archway warns passengers on the upper deck to remain seated and not to touch the wires. It is obviously still a close call as a double-decker bus makes its way beneath in 2011.

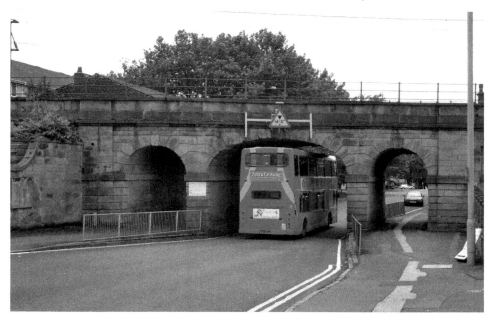

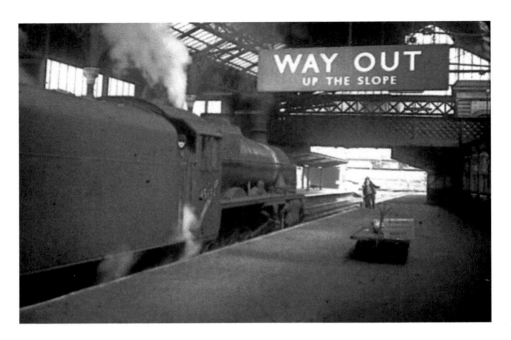

Preston Railway Station – Still Steaming Ahead!

A grimy looking Stanier design engine 45654, named *Hood*, lets off steam at the northern end of the old platform five. Pictured *c.* 1964, the engine was built at the LMS Crewe Works in 1935 and was withdrawn from service in June 1966 as the steam engine era drew closer to its end. Fast track to the picture below, taken in June 2010, and we see the arrival of one of the regular steam-hauled excursion trains. On this occasion, the newly built Peppercorn A1 Pacific No. 60163 *Tornado* was on duty hauling the Border Raider and the usual rush of railway enthusiasts gathered to record the occasion.

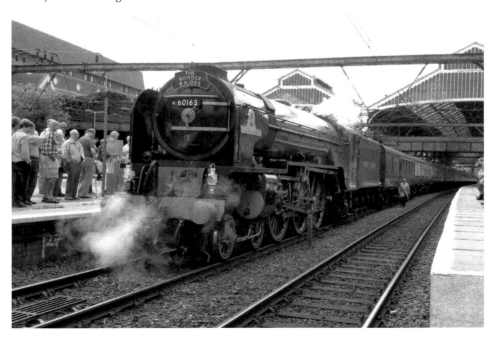

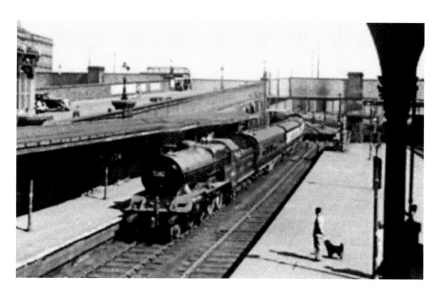

Preston Railway Station View from Footbridge Looking Towards Fishergate
The Fishergate Railway Bridge was constructed in 1877 to replace the Fishergate tunnel and it was a major boost for services in and out of Preston. The new main entrance from Fishergate was opened officially in 1879. This picture above, *c.* 1950, shows a train from the North arriving at the then platform six. The steam locomotive is of the Dreadnought Class 4-6-0 engine No. 50455. On a sunny Saturday afternoon in July 2011, a photograph from the Butler Street entrance footbridge captures a Virgin Pendolino arriving from the North. Little seems to have changed except for the overhead power lines and gantries seen in the later picture. The London to Glasgow electrified railway lines were officially opened in May 1974, meaning the 401-mile journey would take only five hours, with a brief stop at Preston. Not surprisingly, the trains have become even quicker now, with record runs in both directions of under four hours.

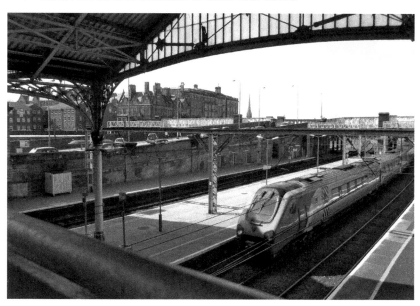

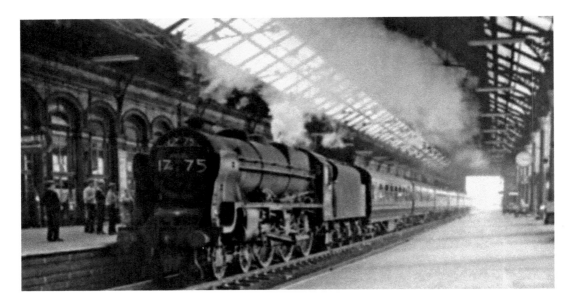

Preston Railway Station – Northbound Trains

September 1962 and a photograph taken by Ben Brooksbank depicts a familiar scene as rebuilt Patriot class engine No. 45535 *Sir Herbert Walker* arrives on what was then platform five to haul a northbound train. This steam engine would have another two years before the scrap yard beckoned. The steam engine era was to draw to a close in August 1968 – the nostalgic last trips from Preston were to Blackpool and finally Liverpool. In reality, the days of steam engines passing through Preston have not gone, with a number of excursions and trips halting at the station each year. The picture below shows the scene today on platform three as a Pendolino named *Virgin Hero* arrives. The station is obviously a brighter fresher place although the station buildings and roof have changed little in sixty years.

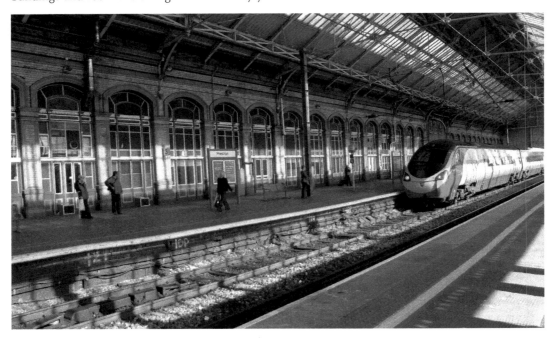

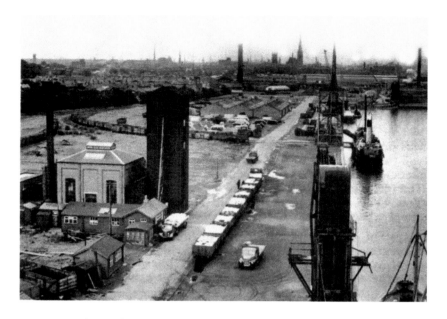

Preston Docks Looking Towards the City

In an article in October 1958, the Preston docks were described as a busy and bustling place. At one stage during the week almost all of the 1 ½ miles of quays were occupied by nearly 17,000 tons of shipping – unloading wood pulp, timber, vehicles, fruit, paper, china clay and fuel. The earlier photograph, c. 1952, gives us a view of a working dock with all the equipment necessary for handling and transporting all the cargo. Opened in 1892, the docks closed in 1981 signalling the end of the Port of Preston. From a similar spot in 2011 the scene has changed beyond recognition. Along this length of dock there are now a number of stores, the most significant being the Morrison's store, which opened in July 1987. It was seen as the beginning of a bright new dawn for Preston's docklands. Once more it is a busy, bustling place.

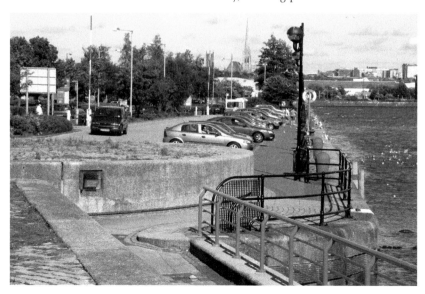

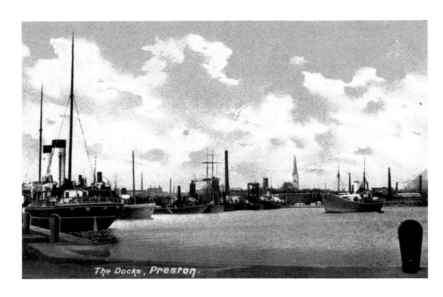

The Docks, Preston

The Docks, Preston

From its opening, the dock was always a place of interest to locals and visitors alike. No doubt this early postcard view was sent far and wide showing Preston as a significant shipping port. The Port of Preston had, by necessity, its own fleet of vessels – be they paddle tugs or dredgers to keep things running smoothly. Many of them were given the names of people who had served the town with distinction, such as Bibby, Forshaw, Maynard, Margerison, Greenwood, Hamilton, Weir and Atkinson. It would appear from the 2011 scene that the Preston Marina is a popular place, with rows of vessels moored where ships once came to unload their cargo. With considerable property development around the dock perimeter along with the opening of public houses, a multi-screen cinema and restaurants, it has been completely transformed in the thirty years since the working dock closed.

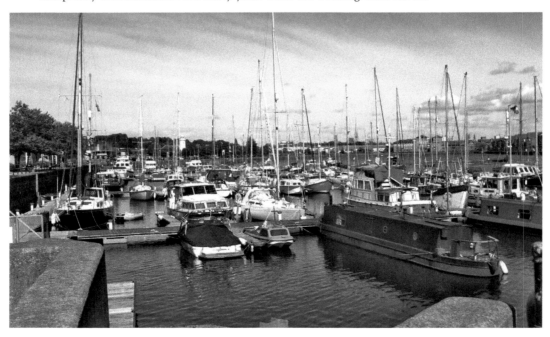

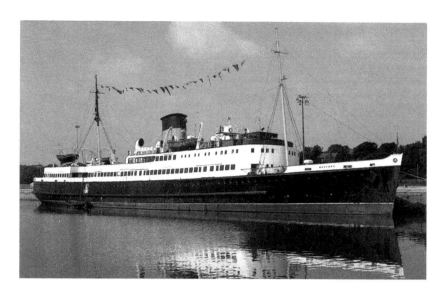

TSS *Manxman* at Preston Dock

The turbine steam ship *Manxman*, built in 1955 at the Cammell Laird shipyard in Birkenhead, had a maiden voyage to Douglas Isle of Man from Liverpool. From then on she sailed the routes to Wales, Ireland and North West England. With the Isle of Man Steam Packet Company having financial troubles, the *Manxman* had its final voyage in 1982 and the scrap yard loomed. A private company stepped in and bought the vessel for £100,000, intending it to be berthed as a centre piece of the redevelopment of Preston Dock. The *Manxman* sailed into Preston Dock in October 1982 amidst a great fanfare, with high hopes for its role as a floating museum and visitor centre. It was used as a film and television location and did create much interest, spending some time as a nightclub. However, when redevelopment of the docks got underway in earnest it was not required. The picture below by Stanley Walmsley shows it departing the docks in November 1990. In the years that followed the *Manxman* had spells berthed in Liverpool and Hull and was finally scrapped in April 2011.

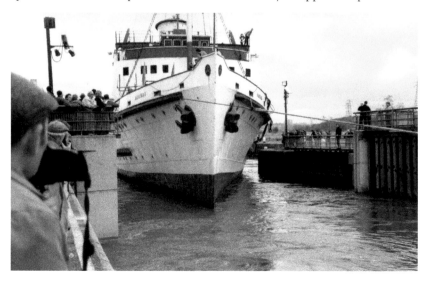

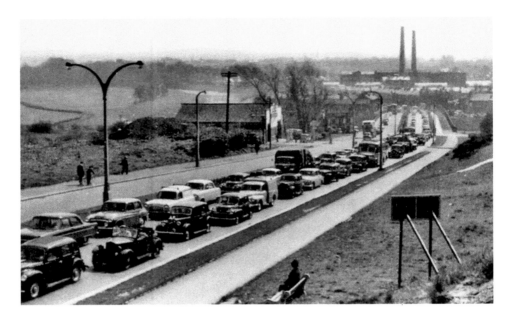

London Road Looking Towards Walton le Dale

This busy thoroughfare, pictured *c.* 1958, crosses the River Ribble over the present-day Walton Bridge, which was built between 1779 and 1781; it was widened around 1936 to cope with increased traffic flow. On the skyline in this image, the tall chimneys that were part of the Calvert cotton mill complex can be seen. The area to the left of London Road was once a vast Preston Corporation refuse dumping ground, eventually developed into a running and athletics track. Just before the bridge on the left, in both pictures, the Shawe's Arms public house can be seen. In the days when closing time was half an hour earlier in Preston, the locals would make their way over the bridge to the Bridge Inn on the south side of the river and enjoy last orders there. In the recent picture the traffic is flowing better, but traffic jams can still be commonplace here.

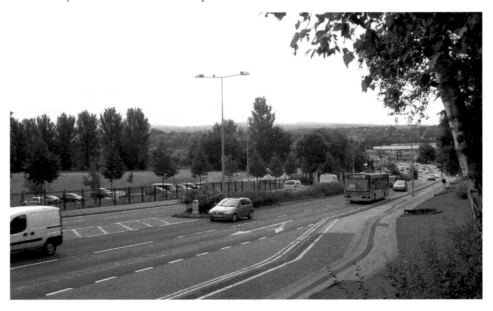

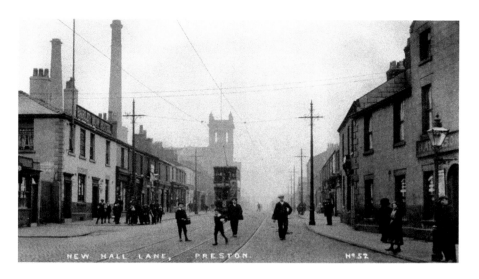

New Hall Lane Looking from Stanley Street

John Horrocks of cotton fame was responsible for the development and densely populated area that became known as 'New Preston' as the New Hall fields were developed. In the foreground of the *c.* 1910 image, to the left is the Barley Mow Inn, and to the right is the Rosebud Hotel, just two of the fourteen public houses between this end and the cemetery gates end of New Hall Lane at the dawn of the twentieth century. The Barley Mow was no longer serving drinks in 1936. Later, the building spent some time as a police station and then a recruiting office for soldiers, and the building is now the Shipsides Marine shop. The Rosebud lingered on until 1988 when it was knocked down along with the nearby streets, and the General Universal Store was erected. Almost centrally placed in both pictures is the Centenary Mill, which was built to celebrate a hundred years of the Horrockses dynasty, completed in 1895. The mill is now filled with apartments, and the old offices are a Travelodge, as the sign reveals in the photograph a century later.

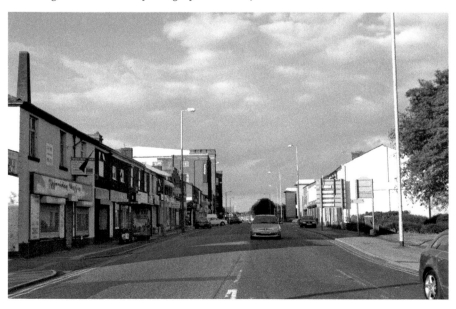

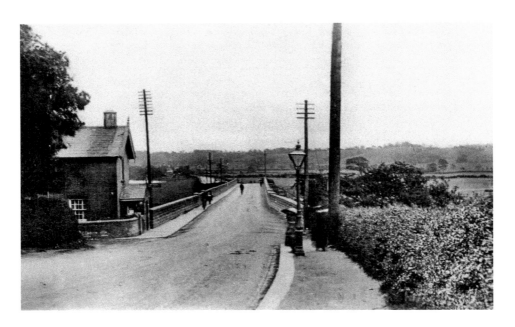

Brockholes – Half Penny Bridge

As the name suggests, this was a toll bridge. Originally, a wooden structure bridge was built in 1826, slightly upstream of the present one. As things transpired it was swept away in the floods of 1840, and replaced by another timber structure. This route to Salmlesbury and on to Blackburn was becoming more important and, in 1861, the stone bridge pictured above was built over the River Ribble. Of course, as the recent photograph shows, the bridge is much wider now and ever since the opening of the M6 motorway in December 1958 it has become crucial to the flow of traffic in and out of Preston. Close examination reveals the original stone wall to the left of the picture, although the toll cottage is no longer there.

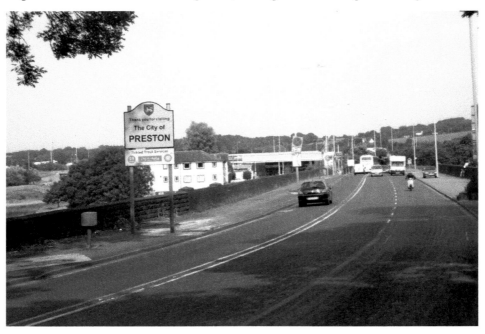

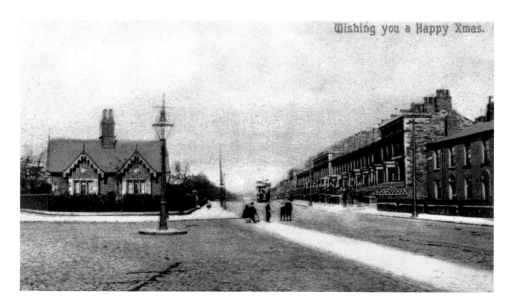

Wishing you a Happy Xmas.

Deepdale Road View

The tinted postcard view *c.* 1906 shows the Deepdale Enclosure to the left and Stephenson Terrace to the right. In the foreground is the old Gardener's Lodge built about fifty years earlier and behind it was the first public observatory in Preston. The telescope was bought for £100 by Preston Corporation and erected on the site in 1881. With free admission it had over 1,000 visitors in the first two years with local folk eager to see the stars – it was later moved to Moor Park. Stephenson Terrace on the east side, consisting of townhouses with front-walled gardens, was built by George Mould over the period 1847–51. It was named after George Stephenson, of engineering and railway fame who died in 1848. In the photograph of 2011, Stephenson Terrace still stands proudly, although instead of being home to fashionable Edwardians it is now home to offices, surgeries and apartments. The Deepdale Enclosure is no longer enclosed by railings, but is still a place for recreation. The Lodge for the gardener to reside in was demolished long ago.

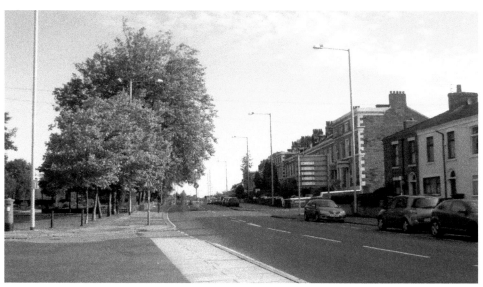

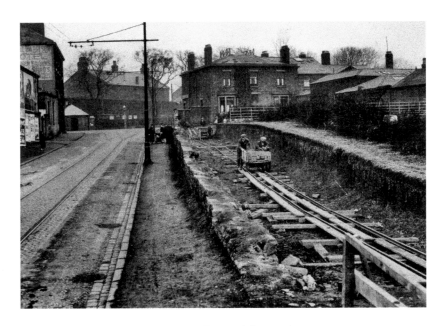

Tom Finney Way, Formerly Part of Deepdale Road

This section of Deepdale Road now carries the name of Preston's famous footballing knight. The first image is from 1931, and workmen are busy widening the road to the junction with Watling Street Road, and it looks a painstaking task. The tram lines and the overhead cables can clearly be seen to the left of the picture. The Royal Garrison public house can be seen to the left in both photographs, eighty years apart, but the old Sumner's Hotel – originally the Prince Albert – on the right was knocked down in 1986, and rebuilt to the side with the junction widened to cope with ever-increasing traffic. In the days when horse-drawn trams journeyed to Fulwood, landlord William Summer, who had his own brewery, ran a livery stable that supplied horses to pull the trams.

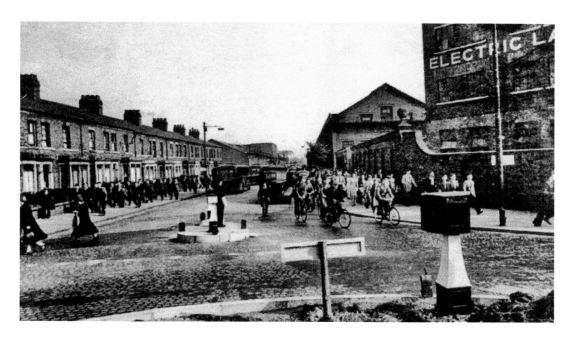

Strand Road from Watery Lane

Maybe it was the petrol rationing, but this view of workers leaving the English Electric factory c. 1945 suggests that pedal power was the preferred mode of transport. Certainly the workers could feel a sense of satisfaction over their war effort, having played their part in the production of the Halifax bombers. The cobbled highway has been coated with tarmac in the intervening years, and although the industrial buildings to the right remain, the terraced homes and factories on the left have gone. There is a reminder of the Strand Road East Works with a walled memorial plaque engraved '1863–1993', the time when British Aerospace left the city to operate from Warton and Samlesbury (see inset).

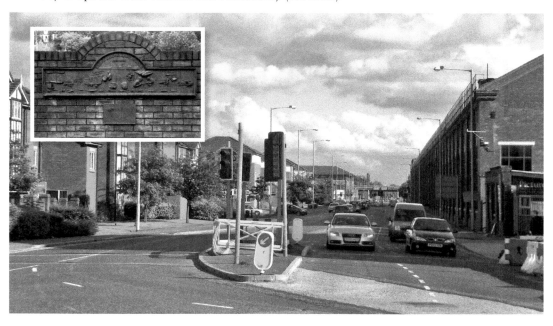

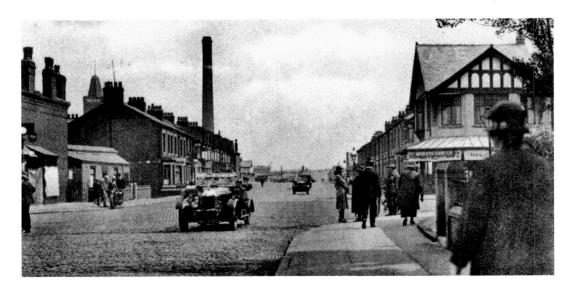

Lane Ends, Ashton Looking Towards Tulketh Mill

The earlier photograph *c.* 1929 captures the moment a fashionable motor car approaches the Lane Ends junction. In its earlier days, this stretch of highway was known as Addison Road, as the route to Blackpool and the seaside its development was inevitable. The Lane Ends area then, as now, was a thriving shopping area and in the intervening years many of the homes on the left-hand side became shop or business premises. In the distance in both photographs the chimney stack of the Tulketh Spinning Company mill can be seen, built in 1905 amidst fields. Originally, the chimney stood over 230 feet tall, but nowadays it is a mere 180 feet high. When the cotton industry went into decline there were fears for the future of Tulketh Mill, but in 1968 the Littlewood's mail order company took over the mill, and since 2006 it has been home to the Carphone Warehouse.

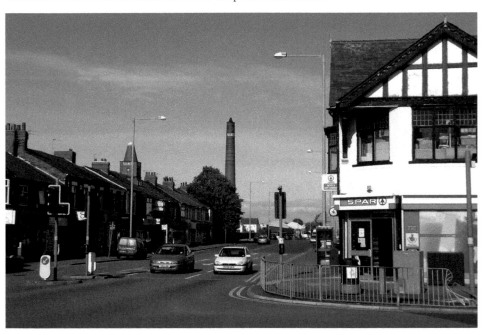

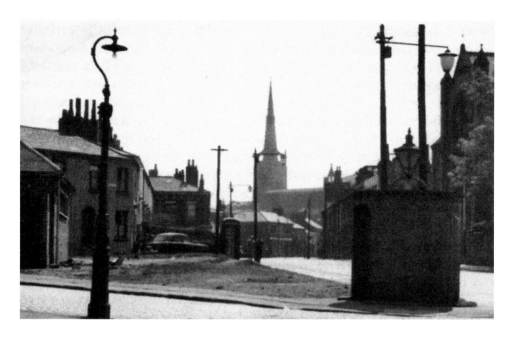

Fylde Road at Junction with Greenbank Street

The spire of St Peter's church, added in 1852, can be seen in the distance in both photographs. In the 1960 picture, above, in the right-hand corner is the Fylde Road Methodist chapel, which was closed a year later. Like the chapel, the Iron Duke gentleman's urinal, the telephone box and the row of property to the left are long gone. The shops along the right-hand side continue to trade and a pedestrian crossing and speed restrictions remind us that this part of Fylde Road is within the UCLAN campus. As the latest photograph shows, the buildings belonging to the university now dominate the landscape.

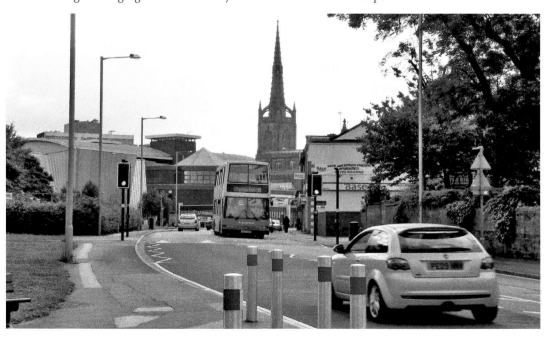

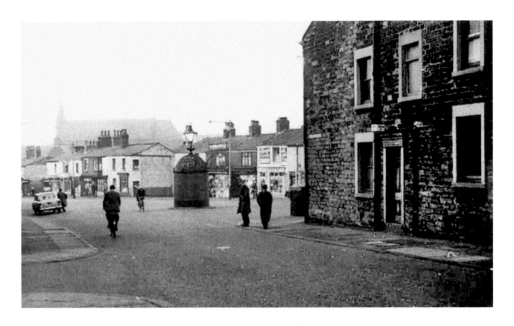

View from Lancaster Road Towards Garstang Road

This image *c.* 1965 gives a glimpse of the junction with North Road shortly before the buildings were swept away along with the Iron Duke gentleman's urinal that holds centre stage in the photograph. In both pictures the Church of English Martyrs can be clearly seen in the background. This building of Gothic design was opened in December 1867, built at the base of what was known as 'Gallows Hill'. The properties on the right, pictured in 2011, behind which is the Church of St Thomas, were in the course of construction in 1968 and a LEP headline declared 'Instant Homes in Preston' – revealing how a company called 'Quickbuild', in association with a local builder, were assembling prefabricated units to construct the new dwellings.

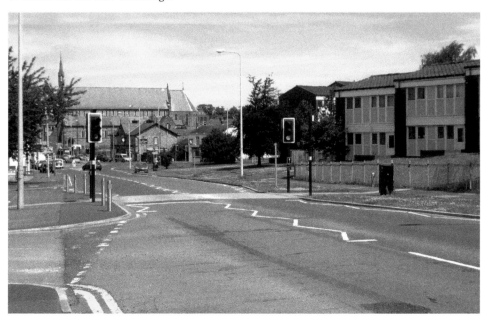

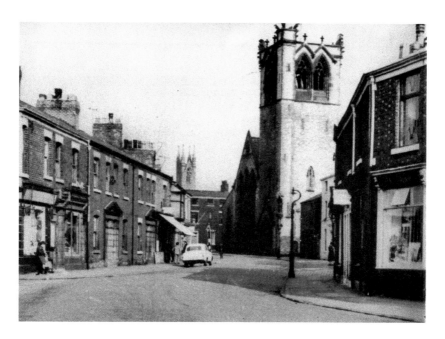

Avenham Lane Looking Towards Queen Street

The skyline of the *c.* 1956 image is dominated by the church towers of St James's on the right and in the distance that of St Saviour's on Queen Street. St Saviour's was opened in 1868 and was once described as amongst the most beautiful churches in town. It closed in 1970 and the parishioners were welcomed into the fold at St James. Alas, within ten years that church building was in trouble with porous stonework and dry rot abounding, and it was closed in 1983. Happily, the church of St James survives in a more modest building on the original site and is part of the parish of the Risen Lord. The present-day skyline is dominated by the multi-storey apartment blocks that replaced the terraced homes in the area – Richmond House to the left of the picture and Carlisle House to the right.

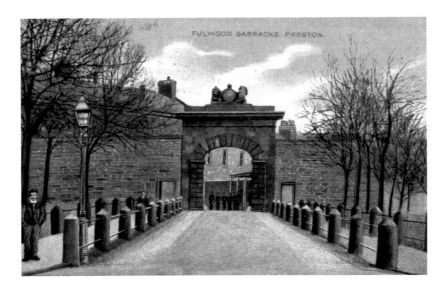

Fulwood Barracks, Watling Street Road

In 1848, the military barracks in Fulwood were completed at a cost of almost £138,000 – only £300 over budget – after five years of toil with over 300 men labouring to complete the task. The stone for construction of the barracks was brought from Longridge, along the Longridge to Preston railway – opened in 1840. Down the intervening years, the soldiers of the barracks have done the city proud defending the country in conflicts far and wide. In April 1962, a two-year modernisation scheme got underway including the demolition of the landmark archway. Fortunately, the magnificent Royal coat of arms that were aloft, carved by Preston sculptor Thomas Duckett, have been preserved and now take pride of place on the grass verge. The annual 'Beating of the Retreat' still draws large crowds to the barracks to see soldiers marching on parade.

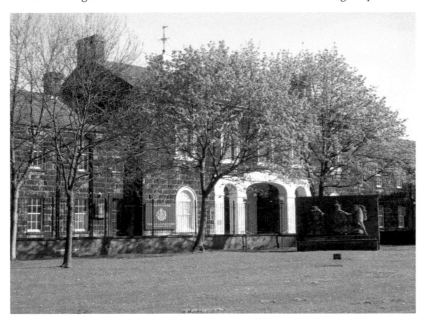

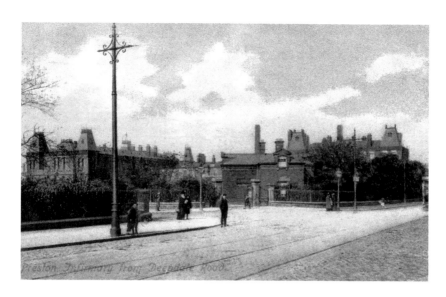

Preston Royal Infirmary – Deepdale Road

This tinted postcard view from 1911 shows the site of the Preston Royal Infirmary viewed from Deepdale Road, with Meadow Street to the left. The Infirmary replaced the House of Recovery and was opened in 1870, with various wings and wards added over the years. In the first year there were just thirty beds available and the total wage bill for the staff was £441. Local architect James Hibbert was the designer of the buildings, and local folk were rightly proud of the place. By the time the NHS was born in 1948, the Preston Royal Infirmary had 396 beds and the hospital at Sharoe Green, Fulwood, had 358 beds, enough to cope with the baby boom that was about to follow. Of course, the opening of the new Royal Preston hospital in Fulwood in 1981, eventually led to the old hospital's abandonment. Some of the impressive buildings still remain and, looking through the remaining gates and stone pillars, you can now see a busy shopping area.

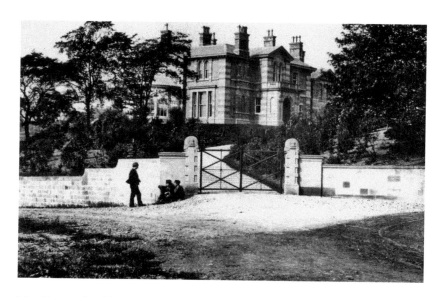

The Gates of Whinfield House, Peddars Lane

Through the gates in this 1862 photograph is the Whinfield House home, which was originally occupied by Henry Newsham Peddar. He was a member of the banking family that played a prominent part in Preston's financial affairs as far back as 1776. However, when his brother Edward Peddar, who was residing at the nearby Ashton House, died suddenly in 1861, a great panic ensued and the bank was forced to close. Henry Newsham Peddar was a soldier and only a silent partner in the banking business, but he was forced to sort out its affairs and, in consequence, both Whinfield House and Ashton House were sold and the family left Preston. The buyer of Whinfield House was none other than Edward Robert Harris, who resided there along with his brother, Thomas, for the rest of their lives. The stone boundary wall and stone pillars can still be viewed from Peddars Lane, at the junction with Riversway, but the Victorian mansion has long gone and private dwellings now occupy the site.

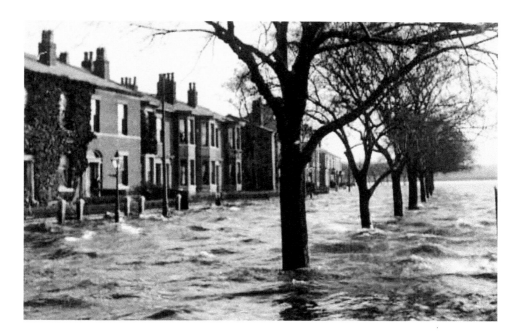

Broadgate Under Flood

The pleasant avenue of Broadgate, which faces onto the River Ribble and leads to Miller Park, had problems with flooding in 1904, and again in October 1927 as the photograph from that time clearly shows. A night of gales and storms led to six or seven feet of water along its entire length, with ground floors and cellars under water. Preston Corporation acted quickly to stem the tide, and the concrete wall was erected and remains today, as seen in the second photograph. The exterior of the dwellings has changed little, despite the passage of time.

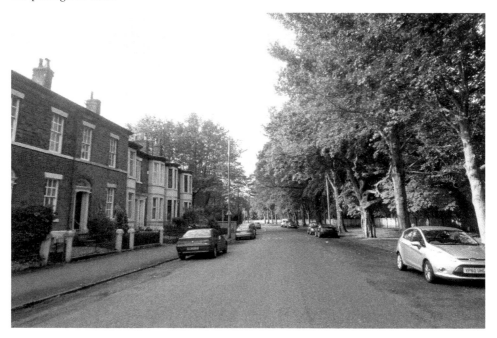

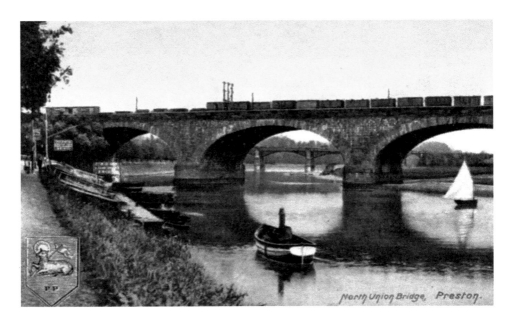

North Union Bridge, Preston.

Messing About on the River

The North Union Railway Bridge, which spans the River Ribble at the riverside entrance to Miller Park, was completed in 1838. A large influx of Irish immigrants worked on its construction. Such was the increase in railway traffic that it was widened in 1879 and 1904, the stone pillars and steel girder frame in the latest image revealing that fact. On the left of the earlier image, *c.* 1902, can be seen boats belonging to Crooks Boatyard, who did a roaring trade at a time when rowing, and indeed sailing, on the River Ribble was a favourite pastime. Through the arches can be seen the East Lancashire railway bridge that divides Avenham and Miller Park, itself opened for travel in 1846. These days a concrete barrier wall obscures the slope down to the river.

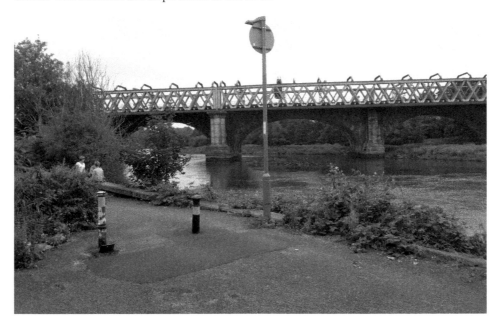

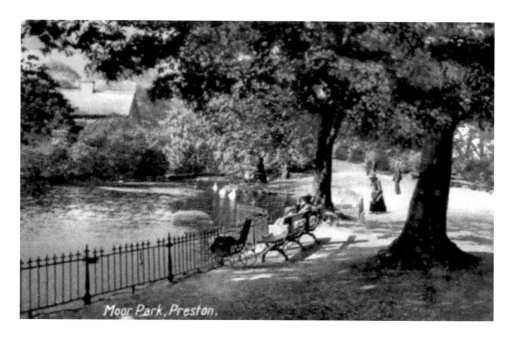

Moor Park, Preston.

Moor Park – Serpentine Lake

The Serpentine Lake within Moor Park was a nineteenth-century delight. With a walk winding along its bank, trees and shrubs aplenty, and a trellis girder bridge crossing the water, it was described as a very sylvan and pleasing place. It is situated close to Blackpool Road – that stretch of road known as Serpentine Road in those days – and next to it is the North Lodge of Moor Park, which dates back to 1836. The genteel folk certainly enjoyed the lake in Victorian days and it remains a pleasant enough place. In the latest photograph, the North Lodge can just be glimpsed through foliage of the trees and 'no fishing' signs stand out of the water to deter any would-be anglers.

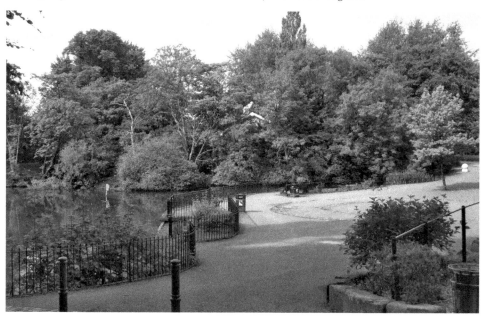

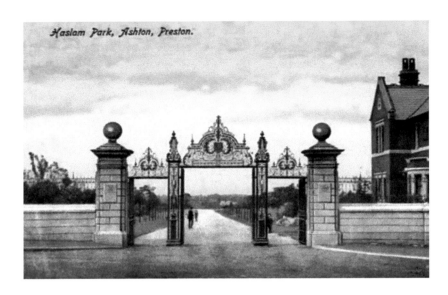

Haslam Park, Ashton, Preston.

Gates to Haslam Park Viewed from Blackpool Road

In 1908, Mary Haslam gave an estate consisting of 46 acres of farmland to the town in memory of her father, mill owner John Haslam (1823–99). Her generosity led to the gift of another 33 acres a couple of years later when the park was officially opened, although incomplete. Landscape designer Thomas Mawson was recruited in 1912, although by then the drive parallel to the railway with its double avenue of lime trees had already been developed. In the decades that followed, a lake was added, and an open-air swimming pool opened in 1932 – then closed in 1987. The building of Tom Benson Way led to the loss of some land by the side of the avenue, but the park was given extra grasslands in the north-east area. The park gates shown in the *c.* 1910 image were lovingly restored in 1999, as the recent photograph shows, and those tenderly planted limes have now become an avenue of tall trees. The Park Lodge to the right is still there, although now hidden behind the greenery.

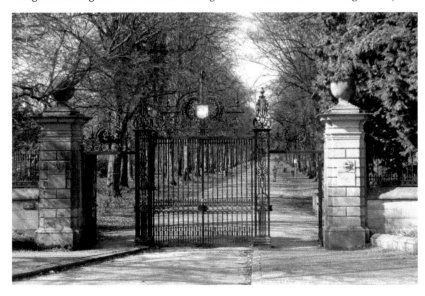

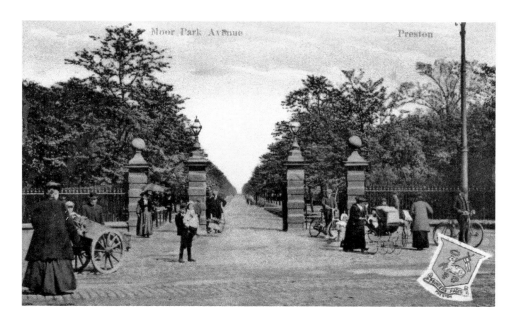

Moor Park Avenue Viewed from Garstang Road

Moor Park is situated on the northern side of the city and it was part of Preston Moor before its enclosure by the Preston Corporation in 1834. The park was officially opened in 1867 following the work of landscape gardening carried out under the supervision of George Rowbotham, the official park keeper, to the plans of the well-known landscape gardener Edward Milner from London. The Avenue itself dates back to the time of the enclosure when a contract was drawn up to create a perfectly straight line of a walk, stretching between the Garstang Road and Deepdale Road, of some twenty-five yards width, which became known as the 'Ladies Walk'. The Edwardian postcard shows a busy scene with people happy to stand and enjoy the experience of having their picture taken. In the 2011 view, only the ornate outer gateposts remain, but the avenue of trees still flourish.

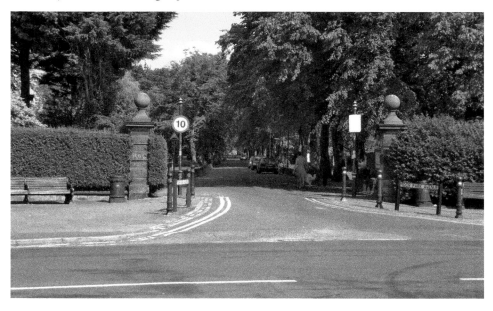

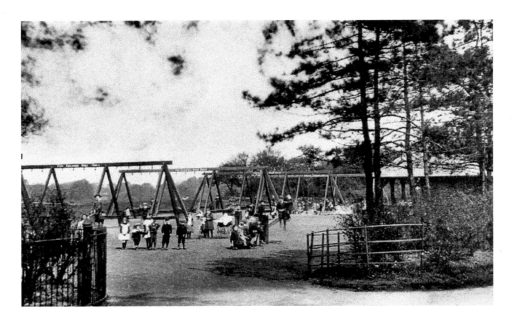

Swings and Roundabouts on Moor Park

These images, just over a century apart, show the development in recreation amenities over time. The postcard view of *c.* 1905 shows the timber-framed swings and seesaw so beloved by Edwardian children. The facilities ensured a regular crowd of youngsters made their way to Moor Park. In recent times, Preston city council embarked on a programme of improving the recreation facilities and, in 2011, at the Moor Park location an 'Adizone' sports and fitness facility was created, alongside the children's play area close to Moor Park Avenue. As the picture below shows, taken on a sunny Saturday afternoon in 2011, the swings and roundabouts are as popular as ever as youngsters have a carefree afternoon of fun.

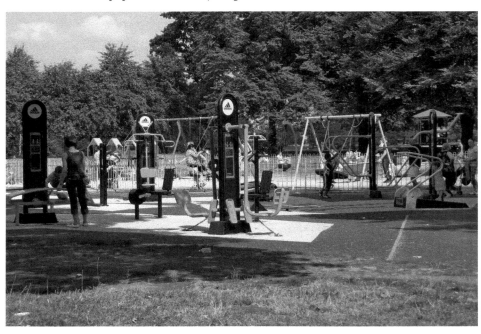

Forty Steps on Avenham Park

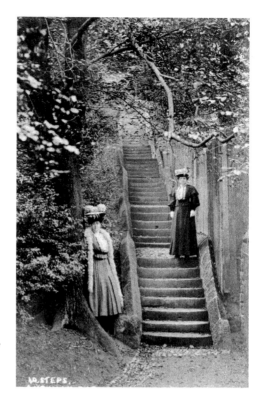

The Edwardian postcard view of the forty steps on Avenham Park, which lead up to a higher terrace, shows that they looked well worn back then. Many people young and old alike have followed in the footsteps of their ancestors and climbed the steps to get a better view of the Avenham valley. The two ladies in the earlier photograph were certainly dressed for the occasion as they posed for the camera. Of course, such a well-worn path needs maintenance from time to time and the steps received such attention in the 1930s. In fact, should you venture into Avenham Park and climb the steps, count them as you go. You may be surprised! In the recent picture, the renovated steps look good and once more local ladies are photographed where those Edwardians once stood. In fact, there are many steps for you to climb in Arenham and Miller parks. Counting as you go, you could climb the steps up to the old railway track between the parks, or those terraced steps that lead to Lord Derby's statue; or even the steps that lead to the Belvedere on Avenham park. Not forgetting the steps that lead to the Avenham Walk. Onwards and upwards.

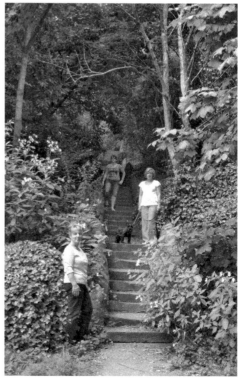

Legs Eleven, or Twelve Even!

A line-up of chorus girls at the Royal Hippodrome on Friargate in the summer of 1936. It was show time from 1905 until 1957 – these girls being part of a Prince Charming production. In 1954, it was the turn of the Preston North End footballers to show a leg, with Tommy Finney on the ball, as they prepared for the FA Cup Final against West Bromwich Albion. Despite being led by Tom Finney, the Footballer of the Year, it was not to be North End's day. A 2–1 lead was eventually squandered and the cup slipped from their grasp.

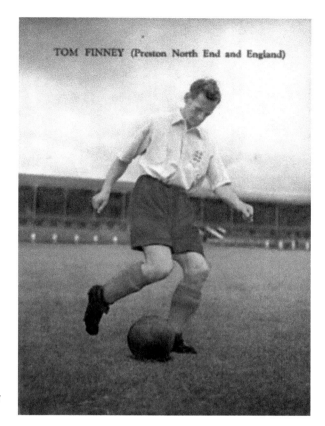

TOM FINNEY (Preston North End and England)

Making Quite a Splash!

The picture postcard shows Tom Finney proudly posing in the England colours during the 1950s. With replica football shirts now retailing at upwards of £40 that would have been two weeks wages in Finney's day. He appeared seventy-six times for his country between 1946 and 1958, scoring thirty goals. Recognised as Preston's greatest footballer, he was born in the city in 1922 and his statue outside the Deepdale Stadium, pictured below, is a reminder of his contribution to the Preston North End cause. He played his final league match in April 1960 and has remained a local favourite ever since. The statue was unveiled in 2004 and captures a frozen moment in time against Chelsea at Stamford Bridge, in 1956. With the match played on a waterlogged pitch, he was almost consumed by water spray after rounding a defender.

Preston North End Football Club, Deepdale Stadium

Deepdale was in a sorry state as shown in the 1995 picture above, taken by Glen Crook, when the old West Stand was being knocked down. It was the start of a rebuilding programme that began with the construction of the £4.5 million stand named in honour of and opened by Sir Tom Finney, the legendary PNE player. In the years that followed the Bill Shankly Kop replaced the old Spion Kop; the Alan Kelly Town End was the next to follow and finally, in 2008, the old Pavilion Stand and Terrace was demolished to be replaced by the new Invincibles Pavilion Stand, named after those heroic Football League & FA Cup winners of season 1888–89. The newly built stadium can now accommodate over 23,000 spectators and it is a far cry from when the North End moved onto the Deepdale Farm land in 1875 where sheep grazed. The photograph, taken in 2011 looking at the Tom Finney Stand, shows the transformation complete with modern facilities inside an all-seater stadium.

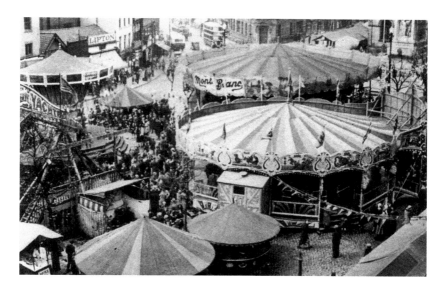

City Centre Fairground

Whitsuntide is always remembered in Preston for its church processions and fairground entertainment. The processions can be traced back to 1840 and the travelling fair to even earlier times. The first photograph *c.* 1930 shows all the fun of the fair with the traditional fairground rides. Since 1971 when the Spring Bank Holiday replaced the movable feast holiday of Whitsuntide, the fairground has continued to call. It is set up as in long gone days, upon the Market Place, along Birley Street and beneath the Covered Markets. The church processions are no longer held, but the fairground still attracts a crowd over the holiday weekend. The recent picture shows the rides on the Market Place on a wet Spring Bank Holiday in 2011. The rides these days are brought in on low loaders and take less time to prepare than in the days of old, when crowds would even gather to marvel at the fairground folk as they erected the rides.

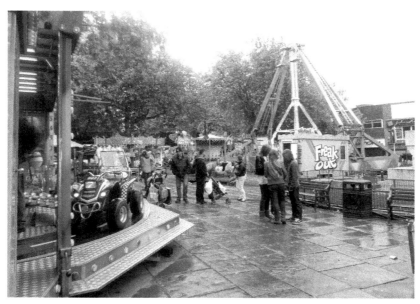

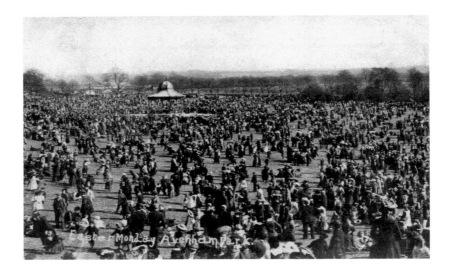

Easter Traditions on Avenham Park

The traditional egg rolling on Easter Monday in Avenham Park is a custom carried out by generations of local folk, as seen in the picture above from Edwardian days. Many of the children in the earlier image will have spent hours decorating their hard-boiled eggs and when the eggs had all gone, an orange could be propelled down the slope. With brass bands, Easter bonnet parades and stalls selling ice cream, periwinkles and coconuts an afternoon of fun was guaranteed. Back in 1926 it was reckoned that the crowd that gathered was over 50,000 strong in the Avenham and Miller Parks by mid-afternoon. The photograph from a century later, by Stanley Walmsley, shows that no matter what the weather is like, the valley still draws Preston folk to make the annual pilgrimage with their children, as their parents did before. Generally, the baskets of hard-boiled painted eggs have been replaced by the foil-covered chocolate eggs, but nonetheless the wide-eyed youngsters have just as much to enjoy as the children of the past.

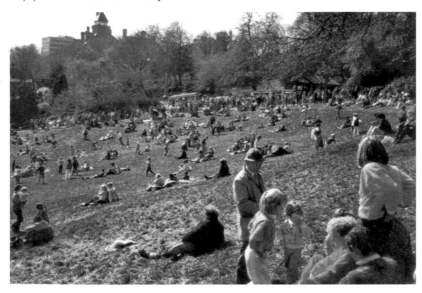

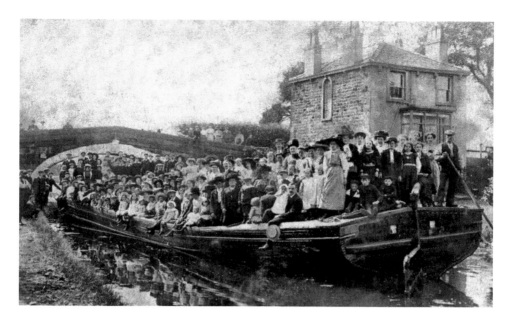

Leisure and Pleasure of the Lancaster Canal

In the main, the intention when building the canals was to improve the transportation of goods as the Industrial Revolution took a grip. However, the coming of the railways changed all that and the canal's future depended on attracting those who yearned to spend some leisure time upon the waters. In this photograph *c.* 1904, the popularity of pleasure boat rides is apparent – it is a case of standing room only! The trip from Preston has reached Cottam, and Bridge House can be seen to the right of the picture. In the photograph taken in the summer of 2011, it looks a more tranquil place as a pleasure craft makes its way through the water. The Cottam Bridge looks as safe as ever and Bridge House remains a fine structure minus a chimney stack or two.

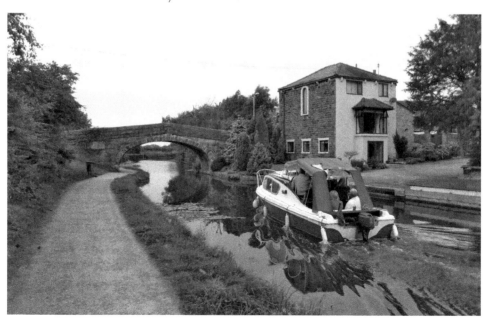

Walking Around Preston

The earlier image is from Whit Monday, 1909 as the annual Roman Catholic Church procession took place. It was one of those wet bank holidays that seem to occur all too often. Dressed in their white frocks and clutching flowers, the girls of St Walburge's and St Ignatius walk along in the pouring rain – no doubt sodden by the downpour. Following them along, as they turn off Church Street onto Stanley Street, is a brass band whilst the banner carriers follow dutifully behind. The crowd were obviously prepared as they shelter beneath a sea of umbrellas. For the colourful photograph below I am indebted to Paul Gunson and the Preston Lancs website. It shows the Caribbean Carnival in 2006 held through the streets of Preston. This event is held each year on the Sunday of the Spring Bank Holiday weekend, and brings an explosion of music and colour to the city streets. With the traditional West Indian steel bands accompanying the many colourful characters with their bright costumes and floats, a taste of Caribbean sunshine has enlivened the city for the last thirty-six years.

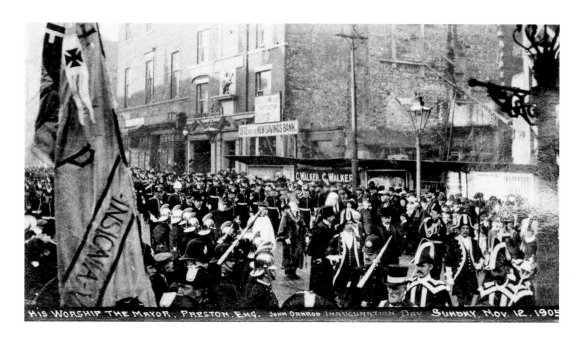

HIS WORSHIP THE MAYOR · PRESTON ENG. JOHN ORMROD INAUGURATION DAY SUNDAY, NOV. 12, 1905

Mayor of Preston on Parade

It is a long-held tradition in Preston for the mayor to lead a parade to the parish church upon their inauguration in the historic role. In this scene from November 1905, Cllr John Ormerod can be seen as the entourage passes the Red Lion public house and the open space that the Preston Savings Bank would soon be built upon. Alderman Ormerod, a leather merchant, had been a member of the town council since 1892. The traditional procession is still carried out today, although the civic year now begins in May rather than November. The Mayor of Preston in 1996 was Liberal Democrat Cllr Ron Marshall and in the inset picture he can be seen walking proudly along on a sunlit morning past the Covered Market along Earl Street. The band played on in 2011, below.

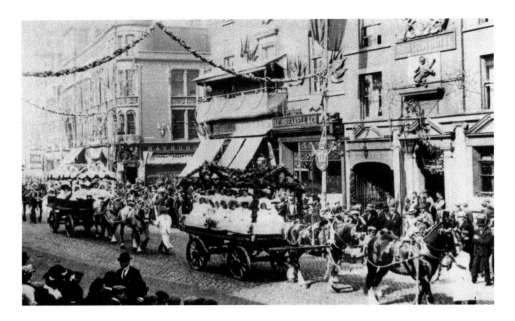

Preston Guild Processions

The Guild processions are a highlight of the week-long celebrations, and the archives of Preston are packed with images from Preston Guilds of the past. Here are just two of those archive photographs that give a flavour of the occasion. Much endeavour and enterprise is needed to produce a walk worthy of the occasions and Preston never fails to deliver. The crowds certainly turn out in their thousands to enjoy the gaiety of the occasion. In the picture above, it is the year 1902 and the church procession makes its way along Church Street past the Red Lion public house as cheering crowds watch from the pavement. In the second picture from the Guild of 1952, the nurses of Preston are on parade in their immaculate uniforms and they receive rousing cheers as they pass the Gaumont cinema and a row of once-familiar high-class shops.

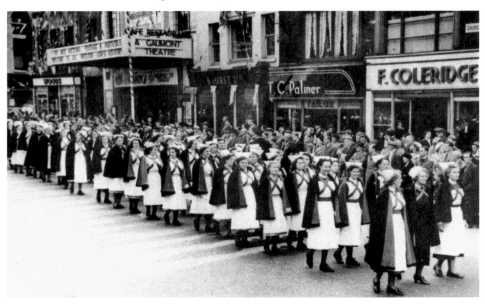

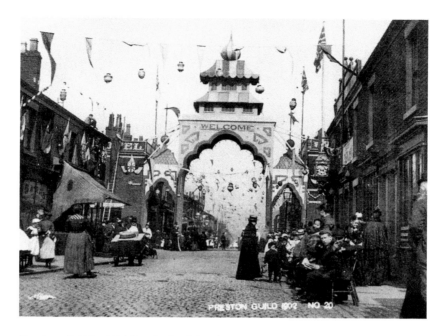

Preston Guild – Waiting in Anticipation

Perhaps it is understandable that when an event occurs only once every twenty years there is great anticipation. The first photograph shows the scene in Adelphi Street at the 1902 Preston Guild as the crowd gather to witness a procession. The pavement is filling up with young and old alike and chairs seem plentiful. To the left, by the side of the Britannia Hotel, a man at the top of a ladder seems to be making a last-minute adjustment to the elaborate decorations. Fast forward to 1992 and once again an eager crowd have assembled on the temporary stands constructed beneath the canopy of the Covered Market in Earl Street and, likewise, on the old Fish Market. Blessed by a sunny day, they await a church procession with brass bands, bishops and the colourful floats about to pass by.

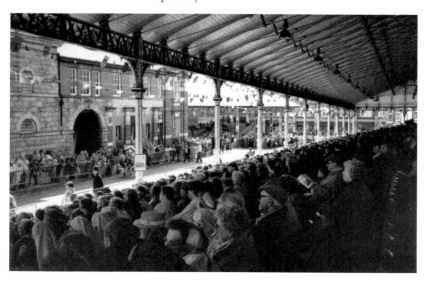